FRANK MECHAU: ARTIST OF COLORADO

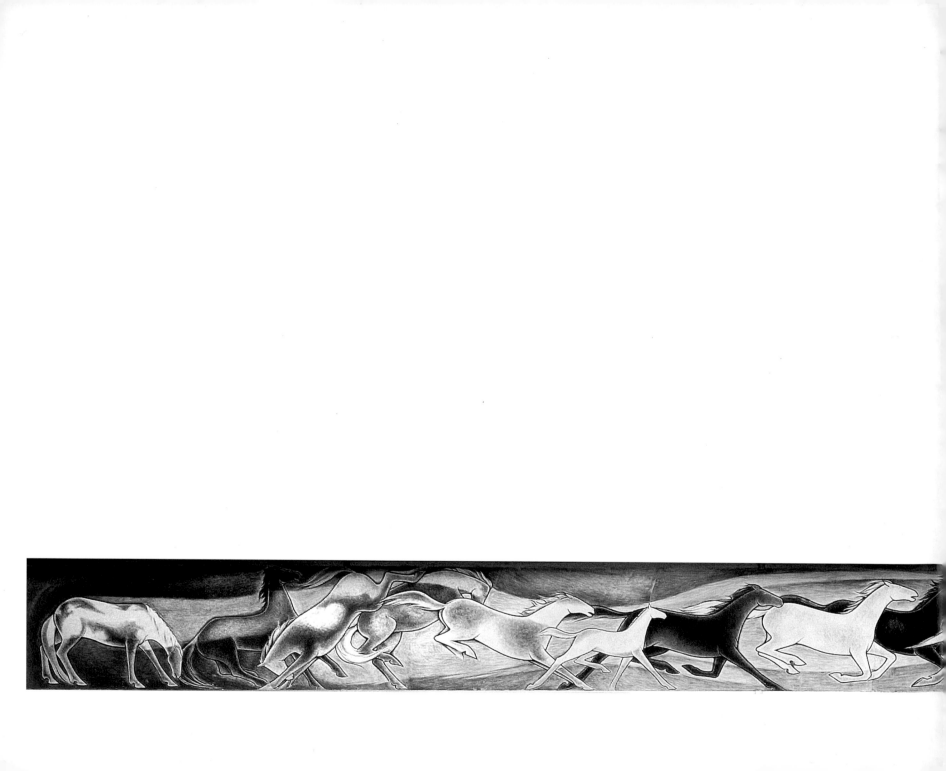

FRANK MECHAU
ARTIST OF COLORADO

by Cile M. Bach

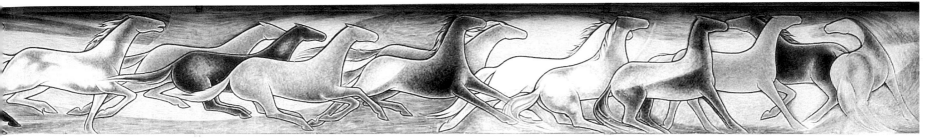

Published by University Press of Colorado
5589 Arapahoe Avenue, Suite 206C
Boulder, Colorado 80303

 A proud member of the Association of American University Presses.

The University Press of Colorado is a cooperative publishing enterprise
supported, in part, by Adams State University, Colorado State University,
Fort Lewis College, Metropolitan State University of Denver, Regis Univer-
sity, University of Colorado, University of Northern Colorado, Utah State
University, and Western State Colorado University.

Printed and bound in Canada by Friesens.

ISBN: 978-1-60732-545-1

Library of Congress Cataloging-in-Publication Data on file.

Book Design by Carolyn Servid
Sitka Willow Consulting | Editing | Design

The paper used in the manufacture of this book has a pH value, tear
resistance, alkaline reserve, and lignin threshold at levels that will
allow the book to last several hundred years under normal use.

Preceding pages:
Wild Horses fresco
Colorado Springs Fine Arts Center, Colorado Springs, Colorado

Dedicated to Paula Mechau
1907-2005

A TRIBUTE

Frank Mechau knew he would be an artist from childhood. He was discouraged from this by his father, a farmer, liveryman, and barber who thought making a living as an artist was impractical, but he was encouraged by his admiring mother. He knew what he wanted and, with great determination, set out in search of it—first in Denver, then Chicago, then New York City. There he met Paula Ralska in a bookstore where he was working. He fell hard for that spirited lady and she for him. They married and, continuing his quest, went to Paris. After three exciting years they returned to America in the depths of the depression and headed for Colorado.

For our father, this was a vitally important homecoming to the landscape and life that he had come to recognize as a fundamental underpinning for his art. For our mother, it was a removal from all that was familiar to her as an urban Easterner. But adapt she did, with pluck and enthusiasm, having been captured by the West's colorful characters and magnificent landscapes. Life unfolded: in the course of things, we four children came into the world.

Our family here pays tribute to both our father and our mother—to our father who, while answering the demands of his passion for painting, lavished loving attention upon us, and to our mother who, while caring for us, encouraged him in his endeavors through thick and thin.

This book is, of course, about Frank Mechau, the artist. But we can also sense our mother's spirit embedded within it. Looking back over our years of growing up and growing older, we can hardly imagine our father's achievements absent our mother's faithful support.

From the time we came to live in the magically beautiful Crystal River valley, our home life was one of shared tasks, food, fun, and evenings by the fire listening to stories read by our mother or singing the folk songs and ballads she taught us. Our father cut wood for the fireplace and cook stove, crafted a fine table for our meals together, a tree

house for adventuring, and stilts to try our luck. Catching trout and hunting deer were both necessary and great pleasures.

We lived in a remote, charming, nearly deserted town with only two or three other families. Even so, our house was often peopled with a variety of interesting characters—local ranchers and visiting artists or writers ready for a jovial evening of eating, drinking, conversation, and singing and, often enough, contests of strength and wit laced with much laughter.

But money was short. Because of hard times, for frequent intervals we had to do without our father when he was teaching at Columbia University in New York and we remained in Colorado. This experience of living without him, though it toughened us, hardly prepared us for his sudden death at age forty-two.

Our mother, though devastated by sorrow, bravely devoted herself to the family, the home, and our father's art. With the reissue of this book, we wish to honor her belief in the enduring significance of Frank Mechau's art and the unstinting care she gave to it over the years.

<div align="right">~ The Mechau Family</div>

CONTENTS

INTRODUCTION

⌒

There are stories scattered throughout human history of rare individuals of remarkable talent, energy, and promise whose lives are unexpectedly and tragically cut short. Artist Frank Mechau was one of these. His artistic career spanned only twenty years—1926 to 1946—but in the course of those years he produced paintings, murals, and drawings of exceptional potency and poignancy. Grounded in his home place of Western Colorado, Mechau created lyric visual expressions of the mountains, valleys, and skies that defined his sensibilities; of the horses and people that he loved; of the fences and fights and fires that shaped the landscape and history of the region. And yet his artistic merits go far beyond regionalism. His work shows influences of the masters he studied—European, Japanese, and Chinese—from whom he developed his own aesthetic of line, design, and composition which, in a singular way, speaks to broader artistic truths.

In *Frank Mechau: Artist of Colorado,* Cile Bach (1910–1991) offers an engaging and thoughtful account of Mechau's career. A writer with strong interests in art, she became familiar with Frank Mechau while working at the Denver Art Museum where her husband, Otto Karl Bach was director from 1944–1974. He had known Mechau in the last two years of his life, and organized both the memorial exhibition after Mechau's death in 1946 as well as a comprehensive retrospective at the Denver Art Museum in 1972. A 1967 commentary on Frank Mechau by Otto Bach is included as an Afterword.

It is interesting to note that nearly every decade, from the 1960s onward, has seen a Frank Mechau exhibition. This might suggest widespread familiarity with his work. Instead, in the tide of contemporary and modern art, Mechau's distinctive work was all too often overlooked by museums and critics in the grip of dominant trends.

Well aware of this, Bach used her monograph to shine fresh light on Mechau and his work. Originally published in 1981 by the Aspen Center for the Visual Arts to accompany exhibitions in Aspen and Boulder, it remains the only substantial documentation to date of Mechau's career. In preparing the monograph, Bach had the good fortune to work with the artist's widow Paula Mechau, who shared articles, Mechau's letters, notes, and

journal entries from the family archives. By incorporating a wide range of excerpts from these archives into her narrative, Bach infused the story with Frank Mechau's presence—his sharp mind, his playful wit, his gentleness, his love of life and family, and his creative passion.

In the introduction to the original edition, Philip Yenawine, then director of the Aspen Center for the Visual Arts, offered this reflection:

> *Frank Mechau merits recognition as a remarkably fine painter. He has penultimate control over such technical formalities as line, composition and color. He was . . . a figurative painter to whom subject matter and narrative content . . .were focal issues, but he also worked within a larger artistic frame of reference, essentially aligned with the aesthetics of the non-western world. . . .*
>
> *Mechau was fully committed and confident that there was expressive meaning in mountains, in mountain people, in the roughness of the West, in animals. He was intrigued by the relationship between painting and architecture, and sought and received mural commissions in abundance. . . . His true understanding of architecture is apparent in "The Last of the Wild Horses". . .*
>
> *The artist's sensitive studies of family and his careful observations of their microcosmic world are as poignant as his landscapes are magnificent. Give him a large Colorado sky, some horses and the people he loved, and he could create painting of and about America in league with the best inventions of 20th-century painting."*

The first edition of *Frank Mechau: Artist of Colorado* has long been out of print. This new edition retains Cile Bach's original text. Her narrative is now supplemented with color images of the paintings, and incorporates some works, including finished drawings, that have rarely, if ever, been published.

We hope the rebirth of *Frank Mechau: Artist of Colorado* will bring his artwork alive for those just now discovering it, and nourish the interest and admiration that many already have for it.

FRANK MECHAU c. 1944

ONE

America is the Place for American Artists

It has been a great experience to study in France, Germany, Spain, Italy, and Holland, but it has furthered my conviction that America is the place for American artists.

Frank Mechau was a complex man with diverse interests. He was an athlete, a scholar, a teacher, a teller of tall tales, a gentle man and a philosopher, but above all he was an artist. He lived his brief life of forty-two years (1904–1946) with gusto, intensity, dedication and hard work. He achieved considerable renown as a painter, but not the financial success awarded to some others of the same period—in part because he was always finding his own way.

Shortly after his return from several years abroad, Frank Mechau said in an interview,

> *America has been altogether too modest in the realization of the rich potentialities which lie within her boundaries and has blindly worshipped everything foreign. It has been a great experience to study in France, Germany, Spain, Italy and Holland, but it has furthered my conviction that America is the place for American artists.*
>
> *I'm glad for the crisis—the Depression—which has driven American talent back to America. Sports, mountains, canyons and the history of the West—of which Colorado has more than her share—are the subjects from which I hope to fashion art.*

The impact that life in the Colorado mountains had on Mechau's work is described in an article by Carl Merey, head of the Denver Art Museum School and author of a monthly bulletin. In the July, 1942, issue, largely devoted to Mechau's career, he wrote,

6

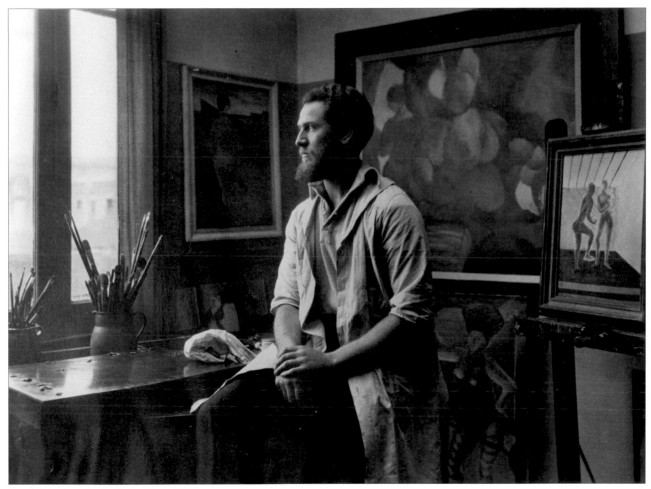

Frank Mechau in Paris Studio c. 1931

Illustration for Richard Aldington's
*The Love of Myrinne and Konallis
and Other Prose Poems* 1926

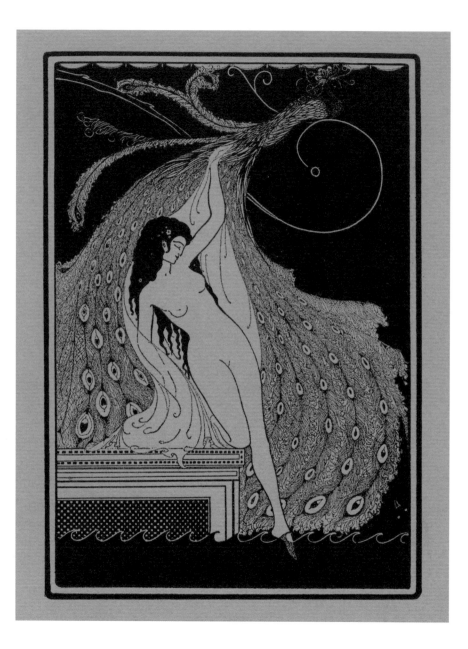

If man is, as scientists say, a product of his surroundings, then Frank Mechau is a part of the vast western slope of Colorado. He is part of the rolling, surging mountain plateaus, the deep-cut canyons, the aspen- and fir-covered slopes, the racing cold, clear valley streams. He is part of the dusty rodeo, the county fair, the football field, and the boxing ring. . . .

He is choirboy in the Methodist church with his foot on the brass rail of the town tavern. . . . As a boy he worked during many vacations in grocery stores, driving delivery wagons, and as a "gandy dancer" on the railroad section gang in school, he took part in all athletics—baseball, football, track and swimming. He was particularly adept at boxing and fought in a number of benefit "smokers" while still in high school.

The artist's family on both sides stemmed from pioneer stock. His grandfather, August, emigrated from the small German town of Mechau to New Orleans at the age of twenty, eventually settling in Missouri. There August met and married Helena Breuer, and the two established themselves in Brown County, Kansas. The couple had seven children, including Frank Albert Mechau, born in July 1874. On Christmas day in 1892, Frank Mechau married Alice Livingston, a Scotch-Irish girl, whose family had emigrated to New England in the 18th century.

Alice and Frank Mechau first settled in Wakeeney, Kansas, where Frank Mechau, Jr., one of four children, was born in January 1904. When Frank was three years old, the family moved briefly to Palisade, Colorado, but eventually settled in Glenwood Springs where the senior Mechau ran a livery stable. When the stable burned, he turned to barbering, an occupation which he followed for the rest of his life.

Thus, the Western Slope of Colorado was Mechau's home. He excelled in sports, was an excellent student and a popular leader among his peers. Even as a young boy, his books, his pencil and sketchpad were as important as his baseball bat or basketball. An early interest in mountain landscape continued throughout his life, and many familiar mountains appear in Mechau's mature work.

Mechau was often his own best biographer. Letters and journals in the family archives are vividly written and reveal remarkable insight into the world of art. The writings

range widely, shifting easily from descriptions of his own paintings to an overall view of American art of that period—the problems and promise of a nation only beginning to formulate an art tradition of its own. His reflections on the masters of modern art—Cézanne, Renoir, Picasso and Matisse—reveal a perceptive independence.

Always a scholar and museum prowler, Mechau found sources of inspiration in such diverse artists as Piero della Francesca, Pieter Bruegel and the traditional Chinese and Japanese painters and printmakers. A deep appreciation of nature is the

First two pages of a longer letter Mechau wrote to Frank Lloyd Wright in 1933.

core of many of his paintings and writings. His conviction that painting and sculpture should be integrated with an organic, contemporary architecture appears again and again, and for him Frank Lloyd Wright was "the prophet of the future."

Mechau's first encounter with the architect's work was after he left the University of Denver for the Art Institute of Chicago. There he discovered Wright's Robie House and Midway Gardens which so impressed Mechau that he felt a strong urge to meet, study and work with the architect. He drafted a letter to Wright in 1933, which included a biographical sketch to serve as an introduction. (The letter was never mailed, because at that particular time Mechau received his first government assignment to paint a mural.) Mechau wrote:

Here follows a raw synopsis, dating from 1922, when I arrived at Denver University on a scholarship from a small town on the Western Slope. At D.U. I took all I could of art, history and literature. The horizon expanded from Zane Gray and Maxfield Parrish to unfold the Russians and the Italian primitives on the outside of the classroom, mixed with boxing (which I agreed to do for the other half of my tuition); a rich year dented a bit by a disturbing hunger and a growing feeling of desolation. The following year I slipped into the Collegiate Military School as an instructor of athletics and went evenings to the Denver Art Academy, where my dream of art creation was chewed into bits before plaster casts and models to be "photographed." In reaction I began writing Baudelairian prose poems and illustrating them somewhere between Blake and Beardsley. Summer took me back to my home, Glenwood Springs, and to the Denver and Rio Grande railroad—a blistering summer doctoring ties, rails and roadbeds, assuaging my other hunger with Haldeman-Julius' blessings, the Blue Books, 5¢ each, and they slip into the hip pocket nicely.

Wondering what the East would hold in the way of art, that fall I rode with several carloads of sheep to Kansas City, pigs to St. Louis and cows to the Chicago stockyards—then a dismal street car ride into town—the balance of the night lodged in the YMCA. Next morning, cleaned and pressed, spirits high, heart in mouth walking down Michigan Boulevard towards the Art Institute, I passed an interior decorating shop.

I had learned how to read hallmarks on silver, knots and designs in Oriental rugs, something of Japanese prints and period furniture. I went in and asked for a job—nearly, but not quite successful. I walked farther, saw etchings in the window and read Anderson Galleries. I went in, asked for the manager—a nice man from Meeker, Colorado— interested—maybe could use me around Christmas. Went into the Art Institute and looked about until mid-afternoon, then had some breakfast at the Y cafeteria. The crowds and bustle scared me. I went upstairs and carefully counted my money, looked up the Kappa Sigma Fraternity, of which I was a member, and took a streetcar to Woodlawn Avenue.

The next week I enrolled at the Art Institute and found a job in Marshall Field's Book Department. At the Institute I was quickly sickened by the classroom procedure and spent the evenings and Sundays at the Ryerson Art Library and working at my decorative illustrations with the object of showing publishers. At Marshall Field's I was placed in charge of the art and standard books, which I found delightful and more fruitful than a flock of years at college. I would stand unmolested in my section, reading book after book, with only an occasional interruption. I saw publishers, got a small job from Child's Life *and then a commission to illustrate a book of verse by Richard Aldington to be published by Covici-Friede. So I went back to Colorado to do the illustrations. Worked hard and patiently waited for the $200 that never came.*[1]

Took a job in a butcher shop, and then opportunity knocked in a challenge from the Western Slope "Tough Boy" purse, $50, winner take all. I got the fifty, a broken nose and hand, and the next week, with summer wages in pocket, saw me going East over the Continental Divide on a stock train—Kansas City, St. Louis, and at last Newark, New Jersey—33¢ from New York—13 days from home. New York—walked miles up 5th Avenue looking for a room-to-rent sign—found one in a side street. At last, I was sure of genuine art schools. I tried one and then another—well, Europe must be the place then. I spent several months searching for employment on a boat—planned to box my way to Europe. Then money gave out and I took a temporary berth in Lord & Taylor's bookshop. I took charge of the fine binding department, enjoyed the work and made some friends—one was later to become my wife.

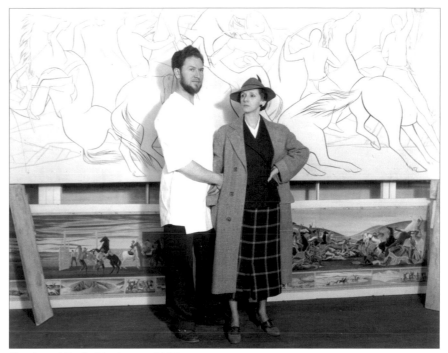

Frank and Paula Mechau c. 1935

Paula Ralska, his wife and mother of their four children, was to be a spirited companion and a source of strength for Frank. When they met she was working in the advertising department of Lord & Taylor; such was their mutual passion for books that Mechau once said: "Our marriage was a merging of libraries." Paula was interested in theater as well, and shortly after she and Frank met she was offered a small part with the traveling unit of Michael Arlen's *Green Hat*. Although Mechau wanted her to stay in New York and marry him, Paula felt she should honor the contract and was on the road for nearly a year.

During her absence, Mechau worked for an interior designer doing furniture and interiors in line and watercolor. "Off-hours," he comments, "I indulged in an extrovert's escape from copying American antiques, furniture, Armstrong floors and other such by drawing mystic, abstract compositions, smelling of Baudelaire, Poe and Swinburne."

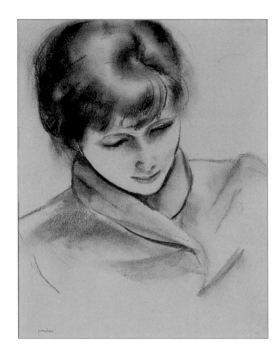

Portrait of Paula 1929
Charcoal / paper
11 3/4 × 9 1/4
Paula Mechau Estate
Palisade, Colorado

When Paula returned, they were married in the New York City Courthouse, and lived in Greenwich Village until 1929. An opportunity to manage the Brevoort Bookshop in the evenings enabled Mechau to quit work with the interior designer. During this period he painted diligently and was pleased to sell three drawings.

After a couple of restless and unsatisfying years in New York, the couple considered either returning to Colorado or sojourning in Europe. Paris had the greater lure, so they sold their books, prints and furniture, and took off for Europe with a one-way ticket on the *S.S. Leviathan.*

Paris was a heady experience for the young and enthusiastic couple: museums, galleries, restaurants, the bookstalls along the quay, writers and artists. They came to know Leo Stein, Henry Miller and many others. Temporary lodging was found in a single room near the Café du Dome, until they spotted a notice of a studio for rent on the Rue de Vaugirard near the Pasteur Institute. They rented it and lived there for six months.

When the Mechaus realized that their funds were reduced to $10, they faced the unpleasant prospect of being deported to the United States by the American Embassy. Fortunately, on the day that their funds were reduced to $5, Paula attended a cocktail party where she met a young man associated with *Vogue* and *Harper's Bazaar*. In their conversation he learned of Paula's work in New York as a copywriter and told her the Dorothy Gray Salon needed an advertising manager to write copy and prepare layouts for the Paris edition of the *Herald Tribune*. The following day she had an appointment

L'Acrobat 1930
Oil on canvas
36 1/8 × 23 1/2
Paula Mechau Estate
Palisade, Colorado

and shortly was notified that the job was hers at a salary of $60 a week. She remained with the firm for three years.

In the summer of 1930, the Mechaus discovered a house with a studio in Montrouge on the outskirts of Paris. This became their home during the rest of their stay in Europe. Now Mechau could devote full time to his painting, and he soon achieved a prominent place in Parisian art circles.

In 1931, Mechau was included in the exhibition, *Les Surindépendents*, sponsored by the Association Artistique and held in the Parc des Expositions, Porte de Versailles. He was represented by five works: "Abstraction Mécanique," "Semi-Abstraction," "Petite Nu," "L'Acrobat," and "La Statue Fatiguée." Although these paintings show the influence of the Cubist movement and also the surreal works of de Chirico, the critics found something more than current trends in Mechau's work.

Maximillian Gautier, critic and editor of *L'Art Vivant*, wrote,

> *There is a profound sense of mystery about the pictures of Frank Mechau. He possesses incontestably the gifts of a colorist which he has put to the service of a powerful style, truly courageous. Mr. Mechau is not content with fixing impressions, he aspires to compose veritable pictures which address themselves to the intelligence. The complete synthesis which he achieves testifies to the relationship between his art and his austere sensitivity to life.*

In view of Mechau's subsequent efforts to unite mural painting with contemporary architecture, the comment of the art critic for *Neue Zuricher Zeitung* is most pertinent, almost prophetic:

> *The works of Frank Mechau synchronize well with modern architecture. They are highly stylized semi-abstractions in broad areas of primary color; his arbitrary use of perspective and the articulate*

Abstraction Mécanique 1930
Oil on canvas
48 × 38
Gerald Peters Family Foundation
Santa Fe, New Mexico

forms in space show a profound imagination. The neo-Classicists have found in this man a born painter.

During 1931, the Mechaus met several American artists who were in Paris on Guggenheim grants, among them the sculptor Oronzio Maldarelli. Maldarelli, greatly impressed with Mechau's work, urged him to apply for a fellowship. He did so, using as references Waldemar George, Leo Stein (art critic and brother of Gertrude Stein), painter Andre Derain, Walter Pach (critic and painter), Maximillian Gautier and Maldarelli.

The weeks passed slowly while the Mechaus awaited word from the Guggenheim Foundation. When it finally came, the letter expressed thanks for the privilege of seeing Mechau's work, but the jury had found others more worthy of the fellowship.

Letter in hand, the Mechaus met the Maldarellis at the Café du Dome. After a few drinks Mechau jokingly told his friends he was writing the Guggenheim Foundation as follows: "I regret to inform you that I cannot accept your decision since I have already spent the fellowship money which I expected to receive."

In 1932 Mechau's work was included in a prestigious exhibition titled *30 Meilleurs Peintres Américains à Paris.* Once again he received acclaim and his position in the art world of Paris was established.

The following quotation, taken from Mechau's unmailed letter to Frank Lloyd Wright, describes the effect the artist's European experience had on his painting:

I shortly cast off Renoir and Cézanne. The Italian Primitives, Persian Miniatures, Chinese and Japanese paintings and prints meant more to me than anything in paint since 1400. I dismissed forever mottled and hatched complementary colors and began to paint with broad areas of simple primary colors. My problem of what to paint was answered by my past experience in America—horses, football, boxing and an occasional nude, as complete as I could construct it. None of current fragments of heads, torsos, apples or bottles.

Mechau then explains his return to American sources:

Before returning to America, we wanted to see more of Europe and so during Paula's vacation periods we travelled—first to Florence and Arezzo, where I absorbed the frescoes of my beloved Piero della Francesca, who represents the most supreme use of plastic elements in history for me. After Arezzo and Piero della Francesca came certain Giottos at Padua, and the color of the Ravenna mosaics. Venice was as formless as her painters—Munich, good beer and well arranged museums—nothing inspiring. Then back to Paris with an extreme desire to get back to nature and life in Colorado. I felt it should be utilized, and I should not be so remote from it. If there was to be painting in America in the future it could not be done at

long distance. Observation and Spengler pointed the obvious direction. So back to Colorado in the midst of the Depression to paint decorations in high schools or colleges at any old price—this was my urge.

The Mechaus' first child, Vanni, was born March 19, 1932, and a few months later the family sailed for New York. Friends attempted to discourage them from going West, saying that New York was the place for aspiring artists. Nevertheless, the Mechaus returned to Colorado just as the entire nation was going through the worst of the Depression. The senior Mechaus had moved to Denver, and the young family was happy to find refuge in one room behind their barbershop. The artist's high recommendations from European critics, along with favorable local press interviews, enabled him to secure a teaching position in Denver's Kirkland School of Art and to deliver a series of lectures in 1933 on contemporary French and American painting.

In June of that year, the Denver Art Museum presented its thirty-ninth annual exhibition of regional artists. Mechau submitted a painting titled "Football Abstraction." It was accepted and awarded an honorable mention. In his weekly article for the *Rocky Mountain News*, Donald Bear, curator of paintings, wrote of Mechau's work: "A semi-abstraction done in clear colors by Frank Mechau and bearing the title 'Football Abstraction' indicates the artist's preoccupation with motion in a restrained manner that places it in the class of the modern and approved architectural painting."

Mechau's evening lectures that summer also were well received. Among those who attended was Anne Arneil Downs, patron of the arts and newspaper art critic. She became interested in his paintings and arranged for an exhibition to be held in the Junior League Club Rooms. The show included some works which had been exhibited in Paris, and three more recent paintings titled "Horses at Night," "Indian Fight #1," and "Rodeo Pick Up Man," whose subjects were to become a source of inspiration for many of his later works.

Shortly after the opening of the show, Donald Bear devoted his entire column to Mechau's first Colorado exhibition:

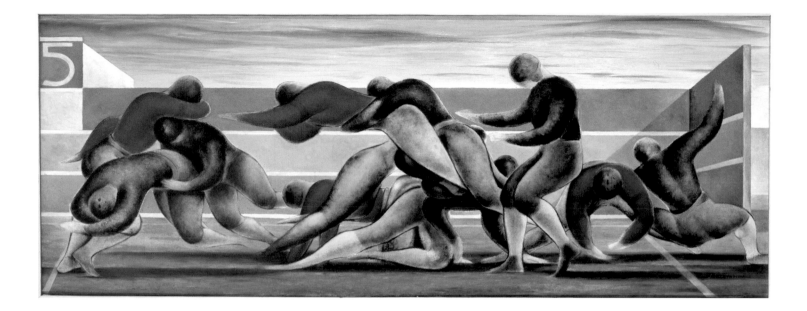

Football Abstraction 1932
Oil on canvas
26 3/4 × 68 1/8
Robert Lewis
Denver, Colorado

About ten years ago in this part of the country any deviation on the part of the local artist from the traditional forms of painting was looked upon with great disapproval by a great many people. The artist who dared experiment with new ideas was branded, so to speak, with the scarlet letter—a large "M" signifying Modernism. He also was more or less shunned by the other artists who virtuously sought the beautiful in purer phrases of the familiar. . . .

Commanding our attention at the present time is an exhibition of paintings in oil by Frank Mechau. This show is now being held for a period of three weeks at the galleries of the Junior League. . . . Particularly we remark Mechau's ability to handle large, simple areas of resonant color that carry for a great distance with richness and clarity. By keeping to ultimate simplicities in form and color, . . . Mechau has endowed his later compositions of cowboys, horses and even Indian fights with an original emphasis. We feel that they could be easily transposed into the art of wall decoration. . . . His work is still the work of a young man experimenting with

Horses in Moonlight 1932
Oil on canvas
30 1/8 × 38
Braddock Financial
Denver, Colorado

knowledge only recently formulated. So far, what he lacks in maturity he makes up in promise.

One of the enthusiastic visitors to the Junior League exhibit was Helen Perry, art teacher at East Denver High School, who invited Mechau to talk with her art class. The success of his teaching at the Kirkland School of Art, the warm response to his lectures from the students at East High, plus the recognition his exhibition had received, encouraged Mechau to open his own school of art.

Because of the Depression, Mechau was able to rent an enormous room in a downtown Denver building for $5 a month, including light and heat. The Mechau School of Modern Art was born, offering two courses: painting and modern advertising art.

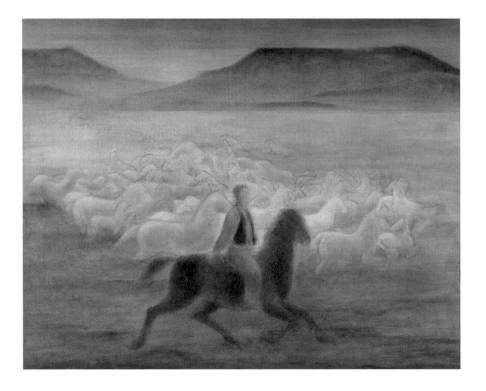

Tuition was $54 for eighteen weeks and a Saturday morning series for $12. The student roster included three of Miss Perry's most gifted students—twin sisters Jenne and Ethel Magafan and Edward Chavez, who were to study and work with Mechau for several years.

Mechau decided to reapply for a grant from the Guggenheim Foundation and was under pressure to complete five paintings to ship East. He was confident this time that he would be awarded the Fellowship. Mechau's remarkable energy enabled him to teach while simultaneously completing the paintings to submit to the Guggenheim Foundation. This combination of tutor and artist was to be a pattern for his remaining years. In the meantime money was scarce, so Paula applied for and received a Civil Works Administration job for $18 a week. Fortunately, the Public Works of Art Program

(PWAP) came into existence shortly thereafter, and prospects for the Mechau family suddenly improved. Paula was able to give up her job and return to her family.

As was the habit of the Mechaus, they spent many evenings sharing books which Paula read aloud in her soft contralto voice. It was at this time that the Mechaus began to read the lectures and writings of Frank Lloyd Wright. Wright's architectural opinions, quite opposed to the then-approved conglomerations of Classical, Baroque and Romanesque architecture, were strongly supported by Mechau, who had always shunned current "isms" and trends. They read in a Wright essay that a young student must have a wise and loving master "who would hold with him that to copy was to cultivate a weakness, to draw from a cast an abomination; that mere imitation, beginning or ending, is forever contemptible and in the fine arts, impossible." [2]

In the same essay, Wright emphasized the necessary discipline which exists in all art, a discipline evident in the many meticulous, preliminary sketches through which Mechau worked out his ideas. As Wright stated,

> *The limitations within which an artist works do grind him and sometimes seem insurmountable. Yet without these limitations, there is not art. They are at once his problems and his best friends; his salvation in disguise. . . . That is what they should teach the young architects in the schools, beginning early. But the schools will have to be taught first.*[3]

Anticipating their second child, the Mechaus sought something more than their one-room apartment with a fold-in-the-wall bed. They rented a small house in Denver's Capitol Hill area, and on October 22, 1933, their second child, Dorik, was born.

Two Horses in a Storm 1932
Oil on panel
15 5/8 × 19 3/4
Vanni Lowdenslager
Gunnison, Colorado

TWO

⁓

Of Landscapes, Rodeos, Horses

*I want to saturate my mind with the rich material
of landscapes, rodeos, horses with which this territory abounds,
and retain in my mind subjects for paintings for years to come.*

Anne Evans was an ardent admirer of Mechau's paintings. The daughter of the Second Territorial Governor of Colorado, she was one of the early members of the Denver Artists Club, founded in 1893. The objective of the club, as stated in the founding papers, was "to foster the development of the arts in Denver." This group planted the seed which was eventually to become the Denver Art Museum.

Evans' imagination and insight found in the government arts programs a welcome opportunity to fulfill the club's objective. She approached George Williamson, regional director of the Public Works of Art Project (PWAP), with the recommendation that Frank Mechau be awarded mural space. Williamson agreed, and Mechau selected an area in the Art Department of the Denver Public Library for his "Horses at Night" design.

This PWAP mural was the turning point in Mechau's career. He suddenly emerged as one of the most promising young artists on the American art scene. Photographs of the small-scale design for the mural were sent by Williamson to Washington, D.C., and on March 8, 1934, Mechau received a letter from Edward Rowan, assistant director of the PWAP in Washington:

I have been looking over the photographs of your mural "Horses at Night," designed for the Fine Arts Department of the Denver Public Library. I want to tell you of the great pleasure this beautiful design and poetic conception have given me. . . . I see

Horses at Night 1934
Oil on canvas
63 1/4 × 144 1/2
Denver Public Library
Denver, Colorado
U.S. General Services Administration
Fine Arts Collection

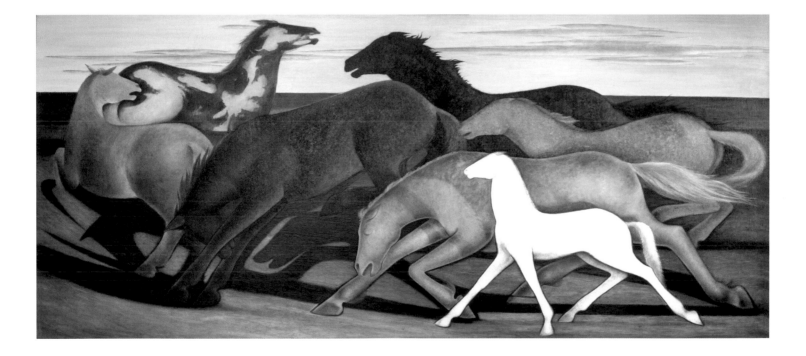

a great many paintings in my work and it is not often that I am moved as deeply as I have been over this painting. . . .

Mechau replied:

It is a rare and thrilling experience to have you like my painting. Such enthusiasm goes a long way toward contributing new forces to future pictures; for it is at times a bitter business to feel oneself a useless metaphysical monk, even though one knows one is of some use.

I have wanted for some time to express my feelings about the PWAP. The project's immediate monetary benefits have made it possible for me and my wife and two children to live normally for the first time since our return from abroad, one and one-half years ago. I speak in the first person although my case undoubtedly coincides with many a creative worker who has felt himself impotent to live or function as an artist these last hard years. . . .

Mechau continues his letter with a brief résumé of his experience in Europe, his encounter with L'École de Paris theories and his decision to return to America. He summarized:

Reasoned I—Europe proper is dead. The only two virgin forces are Russia and America. The beautiful sad tombstones of Europe said, "Go home, young man; try no more to escape your chemical destiny." My findings in the history of art and aesthetics converged towards the American scene with its evident weaknesses and potentialities. One great prophet emerged who had already given the continent its direction in architecture, but who has been little more than the butt of Sunday magazine sections in our country—Frank Lloyd Wright.

Architecture is certainly the future hope of American painting and sculpture; an architecture which evolves honestly from the demand of its materials and needs. Painters and sculptors have, for some hundred years, been divorced from any collective

need . . . which brings us to PWAP and the collective effort toward architectural deco-
ration, even if only in some muggy old Corinthian Courthouse. What a gigantic stride!

The response to "Horses at Night" was immediate and positive. The painting was one of several exhibited in the Corcoran Gallery in Washington, D.C., in April and May of 1934. Edward Bruce, chief organizer of the government-sponsored art competitions, wrote to the PWAP Regional Director in Colorado:

We were all disappointed not to show more pictures in the exhibition, but you will
be interested to know that "Horses at Night" is being accepted as one of the best, if
not the best picture in the entire show. Leon Kroll, president of the American Society
of Painters, spent three hours at the exhibition yesterday and he told me that he con-
sidered it the greatest work of art that had been produced under the project.

The painting was exhibited at the Whitney Biennial and that same year was shown at the Museum of Modern Art, where one critic noted: "At the left of the entrance to the Museum is hung the superb 'Horses at Night' by Frank Mechau—horses in joyous movement, neighing, plunging, rearing in their circling dance, their colors gray, red, dappled and brown, their simplified forms making black shadows on the green foreground."

The favorable response of critics to the Mechau mural had broadened into national recognition when the news arrived that he had been awarded a Guggenheim Fellowship. Because competition for these fellowships was formidable, the May 1934 announcement of Mechau's grant was a double triumph—he was the first Colorado artist to be so honored, and among the first Guggenheim Fellows to be allowed to continue his work in this country rather than in Europe.

Mechau wrote his appreciation to Henry Allen Moe, secretary of the Foundation:

The Guggenheim Foundation can give me this rare opportunity to contact a great,
virgin territory, an area which is equivalent to Continental Europe. . . . In this year

of study I want to saturate my mind with the rich material of landscape, rodeos, horses with which this territory abounds, and retain in my mind subjects for paintings for years to come.

Mechau spent the summer on the Western Slope riding in the high country with local ranchers, and traveling to the rodeos in Wyoming and Montana, filling him with a kind of intoxication. He returned to Denver eager to paint. In October 1934, he wrote Henry Allen Moe:

> Since last writing to you, much paint has run over the palette. . . . I have been commissioned to do a mural for the post office in Glenwood Springs and have rented a kind of temporary studio above a filling station in the heart of town. It seems a bit strange after the life I have been living this past summer. . . .
>
> The raw materials for my sketches come from an area of several hundred square miles and have been arbitrarily used whenever I needed them. A herd of wild horses I observed in the Sopris region stampeded into another territory—the white sands of Alamogordo, New Mexico—to make a panel of architectural forms.
>
> Another five-foot panel, with the Indian Red cliff I told you about before, has stretched and stretched until the design acquired a territory of some seventy-five miles, including the Colorado River and its patterned valley; one end finished in the Fujiyama-

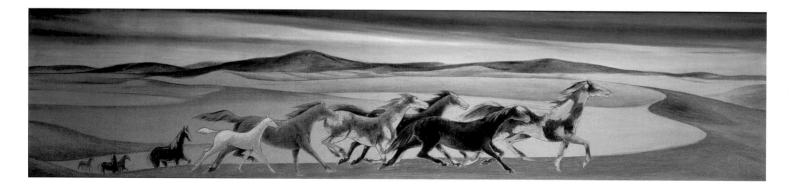

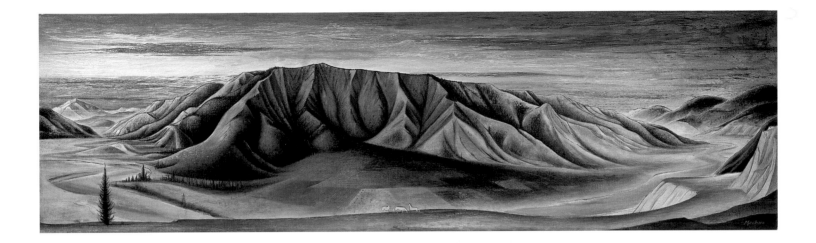

like rhythms of Mt. Sopris, and the other end wends toward the arid buttes of Utah.
A few tiny horses in the foreground give the whole a colossal scale. My first landscape,
and what a thriller for me.

Mechau worked with painstaking precision. While countless sketches preceded every completed work, there is something almost intuitive in his final draft. A singular exhilaration combines with a sense of peace and amplitude induced by his landscapes. In his notes, letters and lectures he often refers to his admiration of Bruegel. As in Mechau's first landscape with its seventy-five-mile vista, Bruegel frequently incorporated the heights of the Brenner Pass, visited on his Italian journey, into many of his Lowland paintings. Mechau shared Bruegel's unerring rendering of time and season by his treatment of light, sky, and cloud formation.

Mechau's concentration and total absorption in his painting is revealed in the following description of the spirited "Wild Horse Race" included in his letter to Moe:

I am tracing on canvas a wild horse race which is a feature of the rodeos. About
twelve untamed broncos are dragged out of the chutes to the racetrack. A team of

27

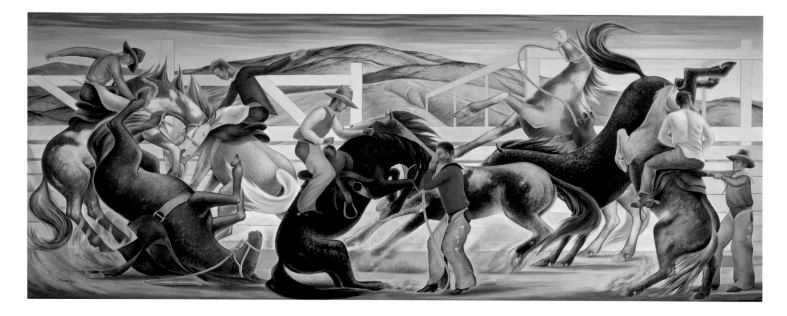

three cowboys to a horse attempt to saddle the frantic creature and ride it around the track. One man tries to control it with blindfold and halter, another employs the effective, primitive device of biting the horse's ear, which sometimes makes the horse rigid and trembling, and sometimes leaves the cowpoke holding a fragment of ear between his teeth. When the signal is given, the saddle goes on and the buster goes up. Pent-up hell breaks loose. Complete chaos—horses plunge and pitch, men are flung and sometimes dragged with their feet in the stirrup; no two broncos go in the same direction or do the same thing. Thirty-six men and twelve crazed horses in a writhing maelstrom of flailing forms. Horses scream, rear and strike, some fall over backwards with the men pinned under them—panic and fear permeates even to the spectators. What a drama of forms and forces, of colors and textures, and a lightning line sewing the cyclone-chaos together.

I also wanted to paint Mt. Sopris. Am sending a rather fluffy photo of it, which is not as interesting structurally as it might be, but I decided to do a two-in-one and arrange a rodeo in the foreground. Cowboys beside the interesting white architecture of the

Wild Horse Race 1936
Tempera on canvas
59 3/4 × 133
Byron Rogers Federal Courthouse
Denver, Colorado
U.S. General Services Administration
Fine Arts Collection

chutes, trying their saddles, putting on chaps and talking to each other, while another group is drawing the names of the horses they are to ride. In the background sits Mt. Sopris, crevices filled with snow, creating a fascinating pattern and flowing down into the architecture of the corrals and chutes. For the first time in my experience I am managing to utilize landscape properties, and what an enrichment it is.

I commenced this rather long letter in Denver and have finished it in Colorado Springs where I have been for two weeks, having been asked to deliver some lectures for Boardman Robinson at the Broadmoor Art Academy. I have only one lecture a day, and the rest of the time I am working on the "Indian Fight." I have felt it quite an honor to fill Robinson's position and enjoy the opportunity to play the prophet, chiefly to propagandize in favor of the local scene and to demonstrate how pictures are put together.

In November 1934, Mechau applied for a renewal of his Guggenheim Fellowship and again wrote to Henry Moe:

Thanks, many thanks for the richest realest year in my life. Now we must see what filters through from the summer's experience. My renewal plea and pictures will arrive there neatly on the stipulated date.

The Mt. Sopris photo was mailed to you. Nice spot, isn't it, for a studio homesite. Land thereabouts can be purchased for as little as $5 an acre. Some day you will come snag a few trout with me, if big game demands too much of you. In the meantime, there are some swell pictures to paint that have instants of excitement in them comparable to mountain climbing . . . nine-tenths hellish hard labor, then the thrill when you touch the untouchable. . . .

Last week brought a wire from Juliana Force of the Whitney Museum, saying they had selected one of my pictures for their Biennial. . . .

In March 1935, Mechau was awarded his second Guggenheim grant, and the next month the Midtown Galleries in New York arranged an exhibition featuring four

Indian Fight #2 1931
Oil on canvas
36 5/8 × 45 3/4
Paula Mechau Estate
Palisade, Colorado

Indian Fight #1 c. 1933
Oil on canvas
32 × 45 3/4
Paula Mechau Estate
Palisade, Colorado

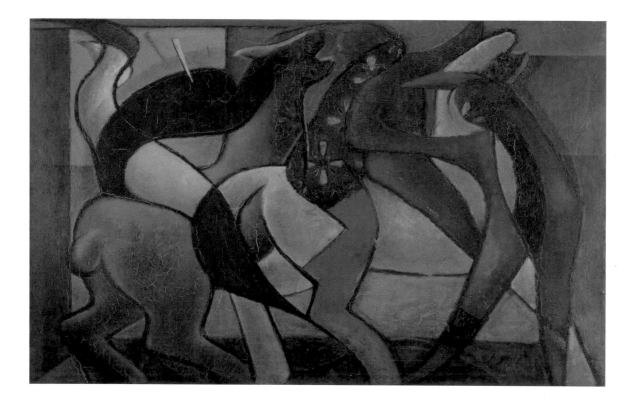

Indian Fight #3 1934
Oil on canvas
35 1/4 × 47 1/4
Sheldon Museum of Art
Lincoln, Nebraska

31

Five Horses 1937
Lithographic crayon on paper
13 7/8 × 18 1/8
Colorado Springs Fine Arts Center
Colorado Springs, Colorado

Guggenheim Fellows. Mechau was represented by "Rodeo #1," "Indian Fight #1," and "Wild Horse Race," three of the paintings which he had submitted to the Foundation for his renewal. At the Whitney Biennial exhibition, Mechau's "Rodeo #1" shared gallery space with such established artists as Thomas Hart Benton, Charles Sheeler, Georgia O'Keeffe and Philip Evergood. "Indian Fight #1" was selected in October of that year for the *46th Annual Exhibition of American Paintings and Sculpture* at the Art Institute of Chicago where it was awarded the Norman Wait Harris bronze medal and a $300 prize.

Critics of the Chicago press found the exhibition disappointing. As C.J. Bulliet, critic of the *Chicago Daily News*, described the show, it was full of a "desperate humor, clutching at whatever pleasure it could find in the sullen array of 'social protest' and of 'drab American scenes,'" in short the kind of propaganda that Mechau eschewed in his

Mechau and Boardman Robinson, 1936

32

Wild Horses (two panels) 1936
Tempera on plywood
45 3/4 × 204
Denver Art Museum
Denver, Colorado

decision to forsake New York for Colorado. Bulliet describes "Indian Fight #1" as dramatic and architectonic, and goes on to say: "Mechau probably has as much right to make his fighting Indians brothers to de Chirico's Greeks as Mestrovic had to convert the noble red man into Scythian horsemen and set them in Grant Park."

For the Mechau family 1935 was a memorable year. A third child, Duna, was born in November, and because of Mechau's success as substitute instructor at the Broadmoor Art Academy, Boardman Robinson invited him to join the teaching staff that fall. His arrival in Colorado Springs marked the beginning of a productive period in which his teaching was combined with the execution of several government murals.

There was also an aura of excitement in the Colorado Springs community because the Fine Arts Center, designed by the distinguished architect John Gaw Meem, was near completion. In April 1936, Robinson and his teaching staff moved into the commodious studio space of the new building. Both Robinson and Mechau were commissioned to create frescoes for the exterior of the building. From the beginning of their association, the two worked as colleagues. They were frequently engaged in similar projects, and often their works were featured in the same exhibitions.

Mechau's interest in fresco painting reached back to the time when he saw the frescoes of Piero della Francesca in Arezzo. He had studied the details of the traditional fresco technique in the hope that one day he might be commissioned to paint one on

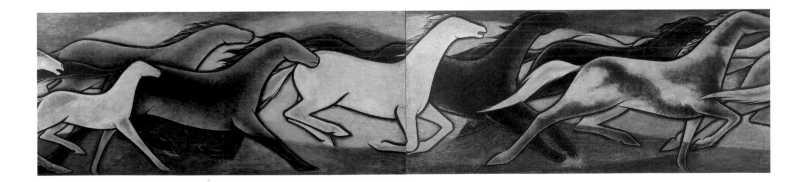

Rodeo #1 1934
Oil on canvas
39 × 84
Denver Art Museum
Denver, Colorado

a contemporary building. Therefore, with intense excitement he began his sixty-foot composition for the Fine Arts Center.[4]

Mechau submitted a small-scale version of "Wild Horses" to the architect. Meem approved the design and requested that Mechau paint a full-scale version in oil on wood panels. As this was Mechau's first attempt at fresco painting he agreed, anxious to see the effect of the design on the building. It also provided him with a sectional guide for each day's work.

Mechau's production in these early years was prodigious. While painting the fresco, he was also creating compositions for several government mural projects. He was at work on an enlarged version of "Wild Horse Race" for the post office in Glenwood Springs. He was also awarded the commission for two murals in the Colorado Springs Post Office. To help with these commissions, Mechau enlisted the assistance

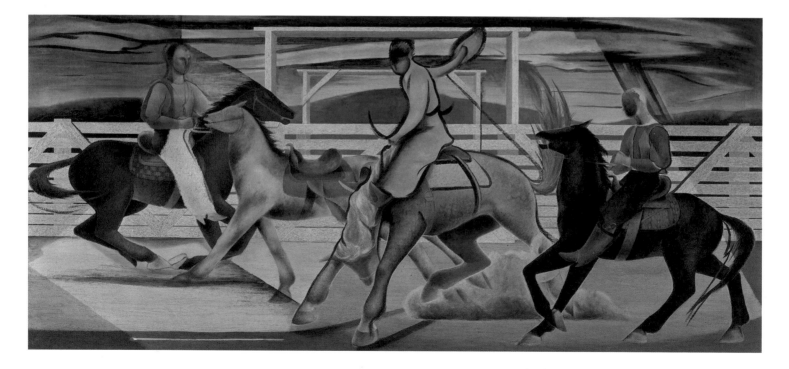

Rodeo Pick-Up Man c. 1930
Oil on canvas
31 3/4 × 39 1/4
Denver Art Museum
Denver, Colorado
Gift of Anne Evans

of his students as apprentices. Apprenticeship was to remain a fundamental principle of his teaching throughout his career.

Mechau, like many other artists at this time, was finding the mural commissions beneficial. Edward Bruce analyzed the Public Works of Art Project in an article which appeared in *The American Magazine of Art*, March 1934:

> *The reaction of the artists to the project . . . has been that while the economic relief afforded them by the project was enormously appreciated and greatly needed, the spiritual stimulus to them in finding that they were recognized as useful and valuable members of the body politic and that the government desired their work has been simply amazing. It has, as many of them expressed it, broken down the wall of isolation and brought them in touch and in line with the life of the nation. It has stimulated them to the maximum effort and aroused their excitement and imagination.*
>
> *It has been a very exciting experience to discover vigorous local art movements all over the country and talent where we did not know talent existed. Artists who were thought of as having only a moderate talent are producing work far beyond and better than they have ever produced before, the artists who were absolutely unknown are producing some of the best work of the project.*

In the late '20s and early '30s many government buildings were constructed in the nation's capital. The Treasury Section of Painting and Sculpture initiated several competitions for the decoration of these buildings—among them the Post Office Department Building. These were an immense challenge and Mechau prepared small-scale designs

to submit. Just before the awards were announced, Mechau wrote another letter to Henry Moe giving his own assessment of his mural designs:

> You may have wondered at my long silence, but as last year's rather extrovert life was abundantly fruitful, with all sorts of dramatic adventures that called for recording, this year's quiet laboring over last year's experience offers no colorful anecdotes to relate. I hardly knew I was capable of working so arduously. For about five months I have scarcely left the studio—certainly an abnormal way to behave. However, the two large and ten small compositions that emerged from the effort carry a reward of their own. It has been a test case for me, and I have come out of my corner with a feeling of exultance.
>
> One panel, "Dangers of the Mail," is composed of a whirling horde of Indians closed in upon an overturned stagecoach with a pile of dead and dying whites who have been partially disrobed for loot. The other one, "Pony Express," is a static contrast to the chaos of the massacre. A pony rider is tossing the mochila (the mail pouch that fitted over the saddle) on to a fresh mustang as the horse he rode into the division point from the last station (fifteen miles) is turned into a corral. The scene of horses, corrals, the station and several riders examining their carbines is starkly placed against a spatial Veronese green sky. One looks down across a wasteland stretch of sand dunes towards a range of mountains stretching the length of the panel.

Mechau then describes the predella, a series of five small compositions below each main panel which highlights events of the "Pony Express" period. In each series there is a central panel measuring 4 × 17 inches, flanked on each side by two smaller panels which measure only 4 × 8 1/2 inches. Horses, figures and landscape are harmonized with remarkable precision. Mechau continues:

> The ten small panels deal with various dramatic incidents of the period, such as Indians attacking and burning a station at night and driving away the horses. (There are fifty-two horses and many figures in the sketch . . .) Another small composition is

the torture of a pony express rider. . . . All of the pictures are fascinating subjectively, but I don't believe it mars the plasticity of the painting, though it may sound like they were mere illustrations.

In most of the compositions I have utilized much of the country around Glenwood Springs. In one of the long central panels (in the predella series), Red Mountain, the Colorado River and its valley were used as an immense backdrop for "The Lead Horse Goes Down." A stream of red warriors have pushed the stagecoach to the edge of a cliff and finally shot down the lead horse, which, of course, piles up the other five horses and the stagecoach on top of them. The horses, Indians and stagecoach are minute spots on the ledge above the river, giving a monumental scale to Red Mountain and the valley below.

Even though I should fail to gain the Pony Express mural it will have taught me much regarding the conversion of experience into art. The sketches for the two murals are now in Washington, the jury convenes sometime in October. You may imagine my nervous impatience to be at this project into which I have poured all I've got. It is by far the most interesting thing that I have ever attempted, and in the light of my love for the region and its people I feel I have an extra-plastic advantage over the other men who have tried the same theme.

I hope you see my sketches, although that is improbable. They, I believe, might speak my thanks to the Foundation, for without your help they could not be. Which smells a little pompous for me to speak about my own pictures like that, but for the first time in my life I actually like my own work, at least in degree.

One can appreciate Mechau's anxiety and concern as he awaited the announcement of awards for this important competition. The suspense was broken on October 21, 1935, when Mechau received a letter from Edward Rowan announcing that he was one of twelve winners which included leading muralists across the country.[5]

Shortly after the awards were announced, the Corcoran Gallery of Art mounted an exhibition of the small-scale designs. Inslee A. Hopper reviewed the show for the December issue of the *Magazine of American Art*. She wrote:

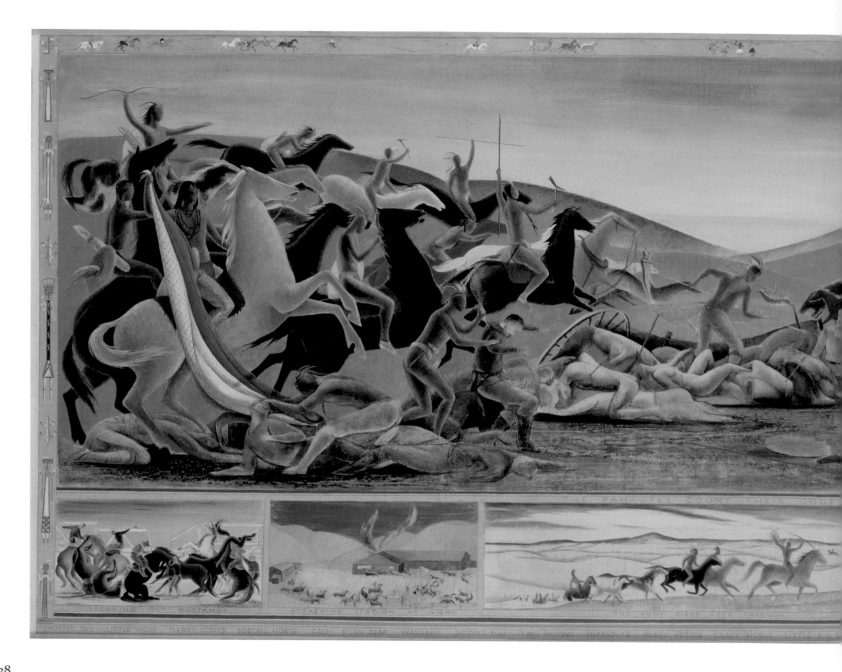

THE PAH-UTES COUNT THEIR COUPS

BREAKING OUT MUSTANGS ATTACKING STATION AT NIGHT THE PONY RIDER GOES THROUGH

SPOTTED TAIL · LITTLE WOLF · PLENTY COUPS · BOBTAIL HORSE · CALF · ROAN BEAR · WASHAKIE · SITTING BULL · TWO MOONS · INKPADUTA · BLACK KETTLE · CRAZY HORSE · LITTLE BIG

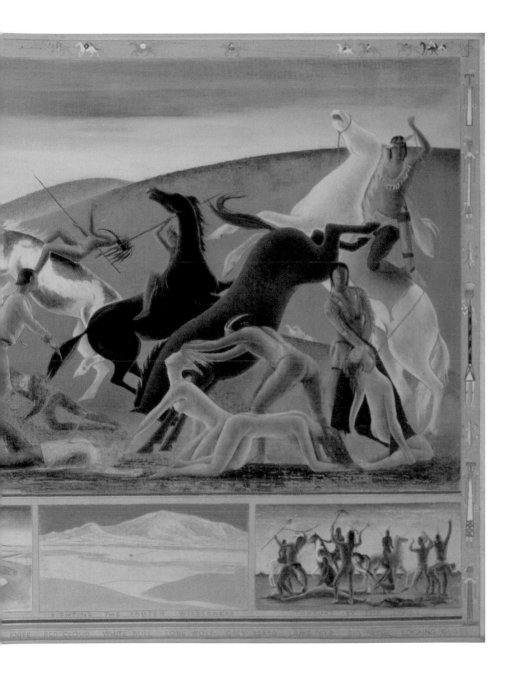

Dangers of the Mail 1935
Oil, tempera, pencil on paper
25 × 54 1/2
Study for Washington DC mural
Colorado Springs Fine Arts Center
Colorado Springs, Colorado

39

Pony Express 1935
Oil on paper
25 × 54 1/2
Study for Washington DC mural
Colorado Springs Fine Arts Center
Colorado Springs, Colorado

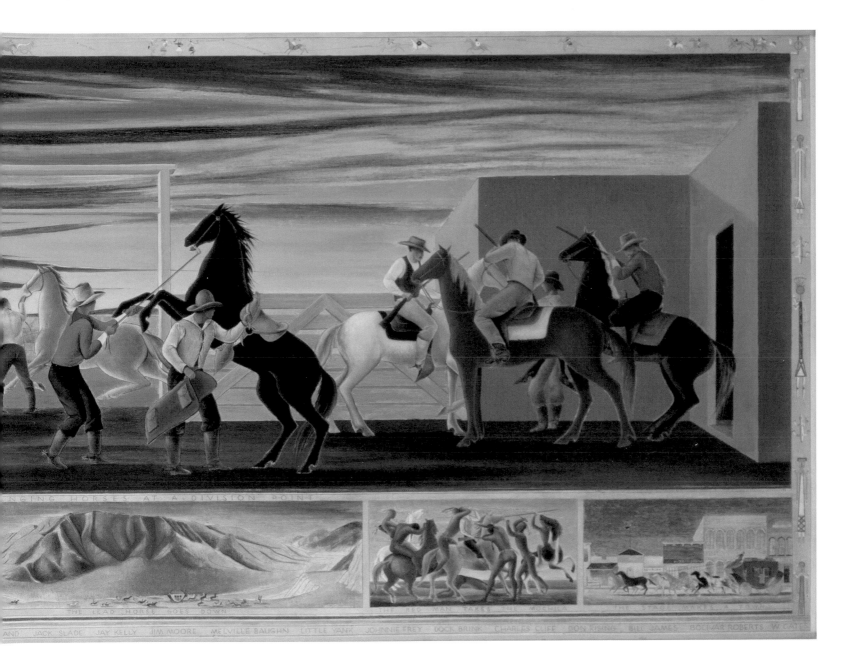

NGING HORSES AT A DIVISION POINT

THE LEAD HORSE GOES DOWN

THE RED MAN TAKES THE MOCHILA

AND JACK SLADE JAY KELLY JIM MOORE MELVILLE BAUGHN LITTLE YANK JOHNNIE FREY DOCK BRINK CHARLES CLIFF BOB RISING BILL JAMES BOLIVAR ROBERTS W. CATE

41

Among the designs for the walls of the Post Office Department Building . . .
those of Frank Mechau are completely indigenous evocations of the western
country which he has observed intimately. There is a compelling mood in each
panel with which he illustrates his subjects and in each case the landscape sets
and sustains the mood.

The incident is generalized into stirring formal patterns and the figures recall
in a more deft way Catlin's wooden catalogue of the American Indian rather than
sentient individuals. There is a curious romantic quality in this painting, however,
which should project perfectly in the finished work for, though the scalping of these
dehumanized figures is thought of only in terms of color and movement, the drama
of the scene is caught in the menacing red of a mountainside or the lowering evening
sky which transcends the incident in "Pony Express."

Another critic's view of the Corcoran exhibition comes from an unidentified *New York Times* reporter who wrote:

By far the most spectacular and exhilarating work is to be found in two panels
by Colorado's famous Frank Mechau. In these exquisitely done studies for his
large panels in the post office building . . . Mechau takes everything that is exciting and
amusing about the same subjects as those used by Currier and Ives and other recorders
of Americana and lifts it into the important tradition of mural painting.

Another unidentified critic made the following comment on Mechau's work in the Corcoran exhibition: "This young artist's rise to recognition reads like a success story. Two years ago he was unheard of, as the popular term for the artist runs, literally starving. . . ." These were the comments of critics primarily interested in the development of modern art, and up to this point Mechau's work had received nothing but praise.

However, fame had its drawbacks. *Time* magazine, in the March 2, 1936 issue, published a full-color double-page reproduction of "Dangers of the Mail," bringing an avalanche of criticism from the press, both national and regional. The *Time* caption read:

Out of hundreds of artists engaged by the government only 20 (12 painters and 8 sculptors) were invited to decorate the new post office; of these, bearded Frank Mechau's bloody massacre of passengers of the Wells Fargo coach and its companion panel of pony express riders saddling at dawn, have been hailed as the finest works yet produced under the Federal program. The illustration above is Mechau's preliminary study. Washingtonians are already wagering whether the white victims at the right will remain nude when the panel is unveiled.

Soon after the *Time* article, lay critics were ready to attack. Receiving praise on one hand and criticism on the other, Mechau was ready to accept the first with appreciation and to challenge the second, for he always enjoyed a good fight.

One of the most amusing criticisms came from May H. Harlow in a letter to Ed Rowan, who forwarded it to Mechau. Mrs. Harlow sanctimoniously lectured that American women should

> *not be so blatantly insulted as to have your Department, the very heart of our Government, permit the acceptance or hanging of "Dangers of the Mail"... to be placed in the Washington Post Office.*
>
> *I add my plea to thousands that our Government not allow further improper and indecent offerings of pictures . . . showing Motherhood's most sacred ties, that our hearts might be broken further. . . .*
>
> *I ask your interest, as it is vital now that this part of our National bulwark be carefully and sacredly respected.*

The most specific criticism came from John Collier, commissioner for the Bureau of Indian Affairs. The following excerpt comes from an Associated Press release out of Washington dated October 8, 1937. It was picked up by *The Colorado Springs Gazette:*

> *John Collier . . . joined a long list of critics and commentators when he poked fun last night at a mural by Frank Mechau, noted young American artist. . . ."Although the*

mural is interpreted by many to depict Indians scalping nude women, apparently after pillaging a stagecoach," said Collier, "Mechau denies the women are being scalped. 'They are only being roughly handled,' he has said.

"That's the craziest thing I ever saw," Collier declared last night. "There could not be any fact like this. It starts being a slaughter against the pioneer women, as I view it. Obviously from this picture they were riding along naked and the Indians scalped them for indecency. . . . The presumption might be the Indians were so shocked by the party of nude ladies with some gentlemen riding across the desert in a large bus that they scalped them."

Mechau's response to Collier appeared in *The Gazette* the following day:

It seems to me that the Commissioner of Indian Affairs has been somewhat loose in his approach, proving once again how ridiculous a good man may become when he willfully wanders into another man's domain.

No artist cared or wished to be considered an archaeologist or ethnologist. My intention was to create an imaginative reconstruction of a massacre into a pattern of forms simplified, and arranged and intensified into plastic inevitability, requiring a certain amount of intelligence and perception on the part of the spectator, thus enlarging his vision and contributing to his experience.

An artist, and those who understand the nature and problems of the artist, enjoys the handling of color, line, the proportion of planes and masses, the variation of textures, etc. It is hardly surprising that since art demands a certain amount of perception and experience in that field that the average person takes a smug shortcut, translating his small emotions into subjective storytelling.

I know it is too much to ask for a little humility; few have the intellectual energy to become appreciators. It is so much easier and exhibitionistic to deride. . . .

It seems extraordinary that Mr. Collier, undoubtedly familiar with the history of Indian warfare and massacres, should take exception to such a mild scene as the denuding of white women captives. Were I to bear down on history, the actual picture of a massacre would be gruesome indeed. Surely it was no picnic on the grass.[6]

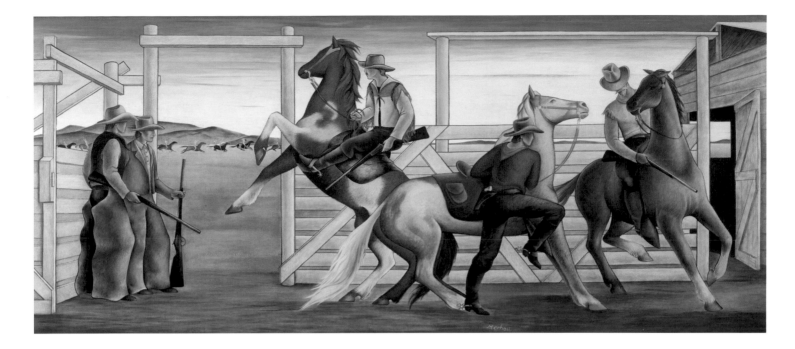

The Corral (aka Pony Express) 1936
Oil on canvas
66 × 144
Byron Rogers Federal Courthouse
Denver, Colorado
(Originally in the Colorado Springs Post Office)
U.S. General Services Administration
Fine Arts Collection

In addition to the work on the Washington post office murals, Mechau had been engaged in developing designs for two murals destined for the post office in Colorado Springs, "Indian Fight" and "The Corral." In fall 1936, the Whitney Museum presented a selection of Treasury Department projects in which the small-scale design for "The Corral" was shown. The exhibition drew immediate acclaim from metropolitan art critics.

The New York World Telegram ran an article which not only attests to the stature of the exhibition but also mentions Mechau as one of the top-ranking American painters:

Even for a single week New York refused to yield the palm to another city as the country's art center. Because Philadelphia on Tuesday opened its big German show, New York came out with not less than twenty interesting presentations simultaneously.

45

Longhorn Drive 1937
Oil on canvas
47 1/2 × 144
Post Office Building
Oglalla, Nebraska
U.S. General Services Administration
Fine Arts Collection
Courtesy of Nebraska Historical Society

First on anybody's list . . . must be the exhibition at the Whitney Museum of paintings and sculpture, executed for the decoration of federal buildings. . . .

It is not surprising that one finds on the roster of exhibiting artists such well known names as Henry Varnum Poor, Reginald Marsh, John Steuart Curry, Guy Pene du Bois, Peppino Mangravite, Frank Mechau, Boardman Robinson, Leon Kroll, Maurice Sterne and William Zorach. . . .

Mechau's teaching and painting schedules were heavy, and he and his apprentices were in the process of enlarging to full scale the designs for the Washington murals, a monumental task. During this time, Mechau's paintings were included in every important contemporary art exhibition. Art critics across the country extolled his understanding of the relationship between form and color—his ability to create clear, significant form, and his genius for infusing life into his composition. Additional recognition came in the form of awards. Reproductions of his work appeared in *The New York Times, Parnassus, Newsweek, Art Digest, Today, The Christian Science Monitor,* and *Town and Country.*

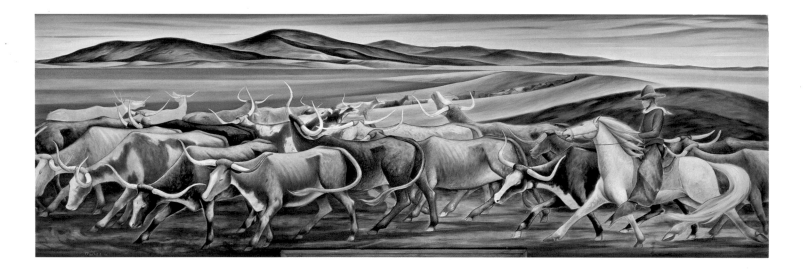

In 1937 Mechau commenced work on a mural for the Ogallala, Nebraska, post office titled "Longhorn Drive." As the year progressed he completed several easel paintings, including 'The Last of the Wild Horses." The idea for the painting was derived from a wild horse round-up which Mechau had been asked to join by some of his cowboy friends. The long journey into the rangeland between Colorado and Utah was accomplished by truck and horseback, and its purpose was to secure horses for shipment to a meat-packing firm where they would be slaughtered for cat and dog food.

The men finally came upon a wild herd dominated by a magnificent stallion. Mechau's reaction to the animals as they reared, neighing and screaming, was immediate, and a painting was conceived. The title, "The Last of the Wild Horses," was inevitable—a lament for the loss of these free and noble animals. Mechau called it his "propaganda picture."

This dramatic painting was exhibited first at the Corcoran Biennial in March 1937; in September it was shown in the Carnegie International, where Mechau was one of twenty-nine American artists included. From there the painting went to the *113th Annual Exhibition of the National Academy of Design*, where it was awarded the Altman prize for landscape painting.

Frank Mechau's pace of production in the two-year span from 1936 to 1938 was impressive, and the acquisition of "The Last of the Wild Horses" by the Metropolitan Museum of Art was further recognition of his contribution to American painting. Accentuating this and other significant achievements was the exciting prospect of his participation in a survey of American art being arranged by the French government and New York's Museum of Modern Art.

News of the proposed exhibition to be displayed in the Jeu de Paume Museum in Paris appeared on November 11, 1937, in the Colorado Springs *Gazette Telegraph:* "Frank Mechau, Colorado's outstanding artist, instructor at the Fine Arts Center, is the Centennial State's sole representative at an art exhibition to be given in Paris next May. . . . The Paris showing encompasses a survey of American art beginning with Colonial efforts, with the emphasis, however, on contemporary paintings."

The Last of the Wild Horses 1937
Oil on canvas
40 × 100
Metropolitan Museum of Art
New York, New York

High Country 1937–38
Oil on canvas
23 5/8 × 48 3/8
Lisa Cattermole
Wilmington, Delaware

50

In anticipation of the Paris showing, the Museum of Modern Art mounted an exhibition in November 1937 called *Paintings for Paris*. Forty American artists, including Mechau, were asked to submit paintings of their own choice for this preliminary assemblage. Those who received invitations were among the most prestigious American painters of the period, and all were eventually included in the final Paris show. However, only five of the group were represented by their original selections. These included Mechau, Franklin C. Watkins, Bernard Karfiol, John Marin, and William Zorach. Mechau's choice was a small-scale design of "Dangers of the Mail," one version of which had been acquired by A. Conger Goodyear for the Museum of Modern Art in 1936.

Henry McBride, art critic of *The New York Sun*, took a dismal view of the preliminary assemblage in an article titled "It Isn't So France" published in *The Art Digest* December 1937:

> *Quite a number of our young artists have been seduced by the idea of propaganda. They wish to preach, to warn, to threaten. The propagandists who have come to light so far are complete pessimists. They have no intention of celebrating the joys of life under a republican government. They insinuate that in our country there is nothing but misery. . . .*

McBride goes on to say that "the 'seeing eye' can see beauty if it chooses and plenty of gaiety . . . and it must be insisted that health is just as good material for an artist to investigate as disease and that 'joy' even better material than despair." McBride's comments reflect Mechau's own orientation. He had fled New York because he found social protest foreign to his mode of expression; he had discovered his roots in the sustaining tradition and beauty of the West.

THREE

⁓

In This Little Town of Redstone

Here, in this little town of Redstone, seventy-five hundred feet above sea level, we function—painting and leading a life that is rich with raw experience.

Because of government-funded mural projects and completion of the Colorado Springs Fine Arts Center fresco, the Mechaus were able to return to the Western Slope in the summer of 1937. They rented a house on a ranch near Glenwood Springs which overlooked Mt. Sopris and Red Mountain with the Colorado River below. When old Paris friends, the Maldarellis, came to visit, the Mechaus took them to the picturesque ghost town of Redstone, thirty miles south of Glenwood Springs. This event had an important impact on their lives. Following is Mechau's description of the town:

Redstone, a model mining town, was built about 1900 by John Cleveland Osgood, president of the Colorado Fuel and Iron Corporation. The town was something of a pioneering step in town planning. Over one hundred cottages were built, with half an acre each for miners and their families to grow their own vegetables. A large building, the Clubhouse, was devoted to a library, card room, billiard room and bar. . . .

The entire second floor of the Clubhouse was a ballroom and theatre. Whenever a play of merit came to Denver a special pullman was sent over to bring the entire cast to play at the Redstone theatre. Laborers who played a musical instrument were hired whenever possible so that Redstone had its own orchestra and band. Extra fine houses were erected for professional members, i.e., the doctors, superintendents, managers, foremen, etc. An inn, with a seventy-five-foot clock tower and imported German oak furniture, was built.

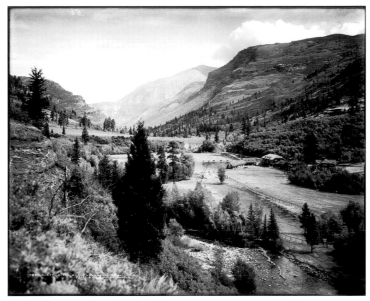

Crystal River Ranch as it was when the Mechaus arrived in Redstone.

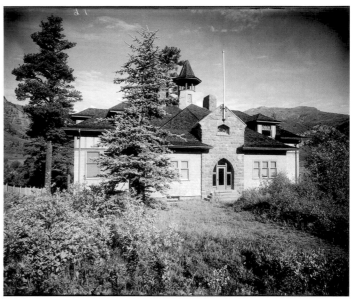

Redstone School House used for a time as Mechau's studio.

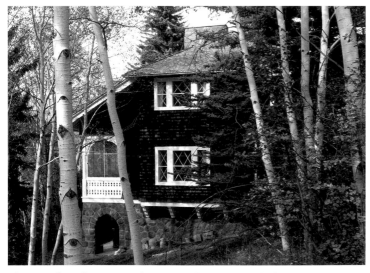

The Mechau home on the Crystal River ranch from 1944 on.

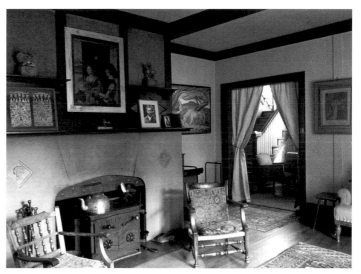

Living room in the Crystal River ranch house.

. . . For himself, Mr. Osgood built a quarter million dollar residence, stables for his racing horses, the Bighorn Lodge for friends of hunting persuasion, with twenty-eight apartments, including a gymnasium, bowling alley and bar. The town functioned for a brief half dozen years and closed up shop when gas outmoded coal in the steel industry.

The Mechau party stopped at the Redstone Inn for lunch where they met Mrs. Huntley MacDonald (J.C. Osgood's third wife). As they were finishing lunch, Mrs. MacDonald told them that the Inn was open for the first time in many years, and that individual houses, ideal for a growing family, were for sale. As she showed them around she pointed out the two houses in the village that were occupied by the caretakers, one of them married to the local school teacher whose single pupil was her own daughter.

The Mechaus, intrigued by one of the vacant buildings and the village firehouse nearby, decided to purchase the property. They returned to Colorado Springs at the end of the summer and scraped together the money for a down payment. On December 27, 1937, their fourth child, Michael, was born. Mechau continued to teach at the Fine Arts Center and was under contract to teach during the summer session as well. At the end of the spring session, the family moved all their belongings to Redstone, which meant weekend commuting for Mechau.

In addition to his teaching, Mechau had completed and entered five mural designs in the Treasury

Battle of the Alamo 1938
Tempera on masonite
15 1/4 × 49 1/2
Paula Mechau Estate
Palisade, Colorado

Department mural competition for the Dallas, Texas, Post Office. They included "Barroom Brawl," "Battle of the Alamo," "Stampede," "Battle of the Adobe Walls," and "Bowie, Houston and Crockett." These compositions are remarkably bold. The forms and the colors are clear, the line charged with energy.

All of the designs submitted were exhibited at the Dallas Museum of Fine Arts, and Elizabeth Crocker, art critic for the *Dallas Times,* in an article dated June 17, 1938, had this to say about them:

> With the exception of the recent no-jury show, there has probably not been hung on the walls of the Dallas Museum of Fine Arts an exhibition as varied in nature. . . .

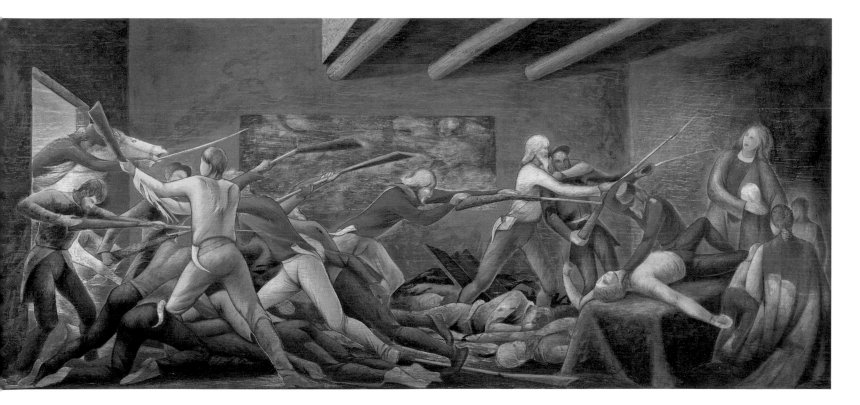

Stampede 1935
Oil on canvas
6 3/8 × 17 1/4
Samuel P. Harn Museum of Art
University of Florida, Gainesville
Gift of Alleen K. and Carl Feiss

Finest painting of the entire group is that done by Frank Mechau, a Colorado Springs artist. Subject of the principal panel, "Battle of the Alamo," was probably against him, but the execution of the design is nothing less than superlative. The rhythmic power of his compositions in all three panels, only the largest of which is exhibited, is quite his best style.

Peter Hurd won this competition, the first time Mechau had lost. However, his designs for the Dallas Post Office were acclaimed wherever they were exhibited, and his "Battle of the Alamo" was included in the Carnegie International of that year. Henry McBride, art critic for *The New York Sun,* wrote:

> *Ten European countries join the USA in celebrating the Carnegie International. . . . Frank Mechau, in his "Battle of the Alamo," makes all his warriors slim and elegant like athletes. There can be no objection to this, of course. His composition,*

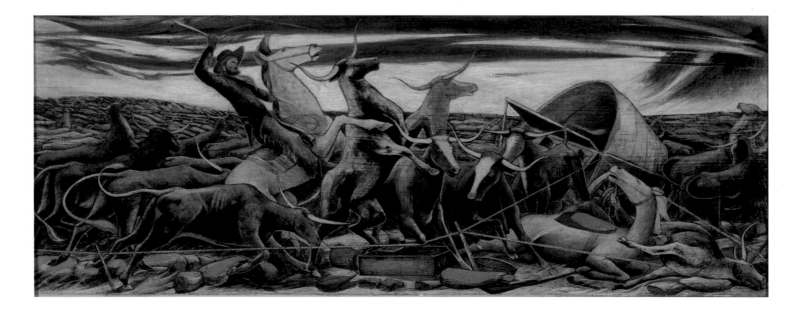

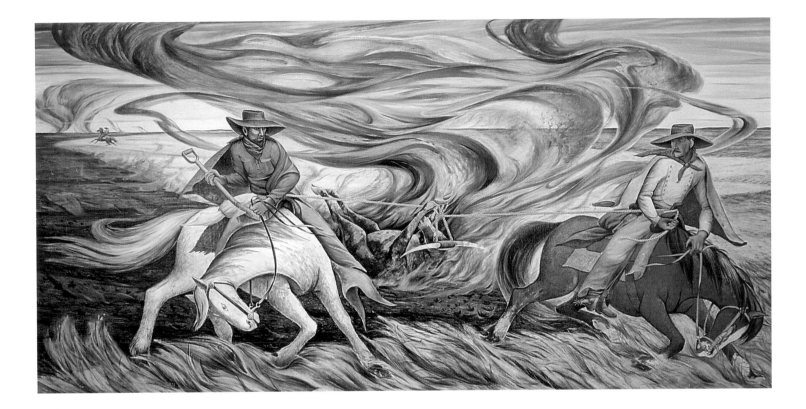

apparently a study for a mural, is conventional but sure. Convention or no convention, Mr. Mechau thinks in terms of beauty and that is something.

In this same period of production, Mechau was invited to submit designs for murals for the Federal Court of Appeals in Fort Worth, Texas. He was awarded the project on the basis of two small-scale designs, "The Taking of Sam Bass" and "Texas Rangers." He was also given the assignment of designing a mural for the Brownfield, Texas, Post Office for which he developed his powerful "Fighting a Prairie Fire."

The highlight of 1938 for Mechau, however, was his meeting with Frank Lloyd Wright. In the 1933 letter to Wright, Mechau said,

Fighting a Prairie Fire 1938
Oil on canvas
66 × 144
Police Department, Brownfield, Texas
(formerly Post Office Building)
U.S. General Services Administration
Fine Arts Collection

I am a painter in search of a direction. For the last decade I have been looking for a living force prophetic enough to pin my faith to. America and Europe provided no school and no tradition. This last month has revealed you as the most living force in our contemporary chaos. I feel the need to be nearer you and your ideas, and I have a proposition which may be reciprocal.

I don't believe it necessary to go into the many reasons why I should be at Taliesin, but I want a more thorough comprehension of organic simplicity than I can get through your books. I want to learn as much as possible of your buildings, past, present and future. I am hungry and want to feed from the source.

The best place in America for me is with you. If you are not in need of me I shall feel terribly grieved. It is hard for you to visualize my aspirations. I have tried to be terse and concise, leaving my spiritual aches and pains for another time. You would like us, I know, because we have followed you with love and admiration, and the feeling that we profoundly need you must have some automatic reciprocation.

We, Paula, Vanni (the baby) and I, wish ourselves into your service. Paula is an efficient secretary and organizer, while I am sure you can use my talents in half a dozen spots. We are willing and anxious to be with you for that privilege and for board and room. If later you see fit to pay us something besides, all the better. We can come on short notice.

Wright came to Colorado to participate in a conference on "The Arts in American Life," sponsored by Colorado College and the Colorado Springs Fine Arts Center, in April 1938. Leaders in specialized fields from Colorado Springs and Denver, and from Wyoming, New Mexico, Iowa and New York were invited to take part in the two-day schedule of lectures, demonstrations and discussions.

Despite the fact that Wright was the keynote speaker at the opening session of the conference, the reception given him was far from cordial. In fact, with the exception of Mechau, members of the sponsoring organizations were somewhat hostile and the press merely duplicated this attitude. On Saturday, Mechau opened the meeting, expressing his long-held conviction that the future of painting and sculpture depended on integrating them into a dynamic form of contemporary architecture. This led to lively

discussion and Mechau's affirmative stand in an otherwise critical atmosphere brought a warm response from Wright. After the conference Wright visited Mechau in his studio where he saw the painting "The Last of the Wild Horses." After studying the composition, he said, "You should have been an architect, Frank, the way you designed those corrals. Come to Taliesen and bring your whole family. We will be good for one another."

Mechau did not return to teaching that fall. Supported by his third Guggenheim grant, he settled into his Redstone studio to complete work on various mural projects. He wrote Henry Moe of his anticipated visit with Wright at Taliesen in Arizona. Mechau's friend supported him in the move when he wrote:

> You have a free hand. Do as you decide will be best for your future as an artist and that decision will be acceptable to us. Just one sentence of caution, and I would say this same sentence if you were "joining up" with anybody else: don't put yourself in any position where you can't do your own stuff. You are an artist; you must be yourself; if not you are nothing. Best luck!

Mechau appreciated the note of caution, but commented in his response, "mediocrity was more to be feared than genius." Moe's advice was no doubt prompted by the fact that Wright was notorious for his dominant personality, and to some it seemed that he was exploiting his apprentices, making them subservient to his own creative genius, his own personal philosophy.

However, Wright's own writings disavow this assumption, especially in his *Genius and the Mobocracy* which is at once a penetrating portrait of the architect Louis H. Sullivan (with whom Wright began his architectural career) and a statement of Wright's own philosophy. One of the chapters in this book is headed "A Good Apprentice is able to serve without becoming a Vassal." This was the formula for the "fellows" at Taliesen; they were to learn, to experiment, to follow orders and blueprints, but to be free, creative spirits.

In February 1939 Mechau visited Taliesen West. He wrote about this experience in his journal and in the letters to his wife in Redstone:

Mechau with Frank Lloyd Wright at Taliesen West, 1939

After lunch, we all drove out to Wright's camp about 15 miles from Phoenix. I was shocked on arriving to behold gigantic monumental foundations, which proved not to be foundations but a long, sturdy building several hundred feet long, with wings of other sections of the building at right angles and tangents to the main mass of the drafting and living room quarters. The stone masonry was thick and fortress-like, with no perpendiculars. The walls went up at angles like a cornice of a Mayan temple—the walls themselves created most beautiful abstract sculpture.

In the evening we had dinner at Wright's little wood, canvas and copper-covered house. F.L.W. said some very interesting things. We spoke of painting, sculpture and music and their common sources, F.L.W. saying that all three belong to and grow out of architecture; that painter, sculptor and musician should be familiar with the organic process of architecture (not with the small mechanical problems of stress and strain). To which I readily assented, but made the point that there were painters and musicians who intuitively know of those necessary architectural elements without having knowledge of architecture itself—gave Bach and Beethoven as examples of men who came after the Gothic will to build had subsided. Also mentioned Hokusai and Hiroshigi as men he liked who were definitely architectonic but did not function alongside of architects. . . .

I was looking at a magnificent cloud formation toward the range when F.L.W. walked up and said, "That is the reason we don't need anything in the way of representational art here, or on any real piece of architecture. When you can show me an abstraction or extraction of the thing we are looking at which is more real in structural essence than the visual effect itself—then we can come together." There is of course the problem and the debate. I shy away from most ornament as something pretty sterile. However there is the focal point of our problem—and hardly a new one.

Worked almost all of yesterday on the "Forest Fire," laborious going with the countless distractions, the fellows stopping every few minutes to look—several were impressed, including Mr. Wright, who invariably leaves some keen remark behind for me to ponder. At dinner, F.L.W. and I sat together again, had quite a talk, with the

high point landing on our future. I explained that the Ft. Worth mural job had to be executed within eight months and that the reward would not be sufficient to keep us through the winter. He questioned me more closely about our financial situation, then said, "Frank, we'll do something about that, either get some work for you to do or fix it somehow. I'll think about it—let's not let the contact die, bring Paula and the children. We need them all, they will do the Fellowship good! . . ."

Next day—chilly and blowing hard—so I worked on the "Forest Fire." F.L.W. came in for a look at it, said he liked it very much. He seemed to keep steadily on the rounds of the building, to check on the different sections as they progressed. . . .

F.L.W. will not hear of a fresco on his building, and I'm not at all sure it would enhance it—only maybe—sculpture would be grand. . . .

I plan to ask if we can't join the camp next year. After the structure is completed we could better tell what might be done. . . .

Have taken a measurement of some walls in the kitchen for a fresco. Want to have one more good talk with F.L.W.—because I've an idea of doing murals for his clients at a percentage for the Fellowship.

Just before leaving Taliesen to return to Redstone, Mechau wrote to Henry Moe:

You may have wondered how Frank Lloyd Wright and I get along; most everyone had this same feeling before I came. Naturally, I began to feel somewhat worried, but I am happy to report that F.L.W. is one of the most kindly and human of people. We harmonize well, and I am sure that I have gotten a great deal from him—now it's up to me to carry on into painting ideas I have had in the past towards a more organic unity.

Wright, together with about 30 young men, is creating an extraordinary summer camp here about 30 miles from Phoenix. The building is of massive desert stone, picked on the site and stuck together with concrete. Long, thin beams carry a vast ceiling of canvas on individual frames that overlap each other like big shingles. It is well nigh impossible to describe verbally, so I will send along some snaps when they are developed. They will give only a fragmentary idea, as the building is huge.

Forest Fire c. 1940
Oil and tempera on panel
28 3/8 × 69 1/8
Paula Mechau Estate
Palisade, Colorado

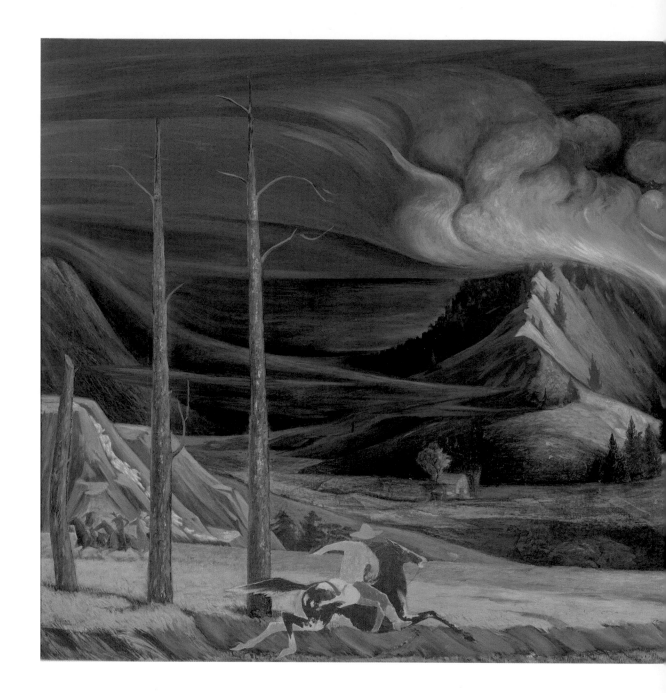

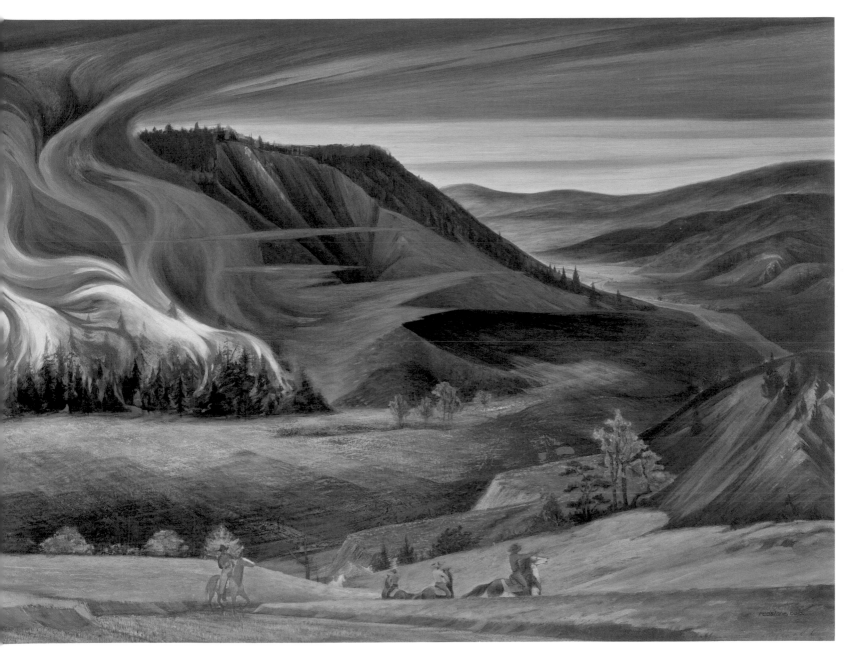

As for my activities, I have been working on a "Forest Fire" panel which I brought from Colorado, and doing a lot of reading on architecture—such as Sullivan's Kindergarten Chats *and* Autobiography of an Idea—*Hitchcock's* International Style—*Le Corbusier,* Towards a New Architecture—*Curt Behrent,* Modern Building, *and several others including that best of all Guggenheim fellows—Mumford's* Technics and Civilization *and* Culture of the Cities.

My object has not been entertainment, but I am anxious to see as clearly as possible what has happened and what might happen—particularly in the field of painting and sculpture as it begins to flow back into architecture. Painting and sculpture simply can't exist independently—and on the other hand it can't be a shot-gun marriage.

And, too, I believe that I should teach every other year or so. Being an ivory tow-erist is sweet but dangerous—I want to keep on my running spikes for some years to come. Jack Briggs, of Columbia, asked me to teach the summer session in painting, but it couldn't be worked into the schedule of things, as I felt it was more import-ant to spend some time here with Wright. I also must execute three murals for the new Fort Worth Courthouse by fall. Then I'll be free and eager—in search of a job with some progressive outfit. Please keep me in mind if something interesting passes your way.

The winter at Redstone was, as usual, magnificent. Fifteen feet of snow, packed to some four feet on the level made the deer and elk come down by the hundreds. The ski-ing was more sporting than the hunting, which can hardly be called more than butchery.

The children, all four, haven't had a touch of anything (excepting an icicle on the head) since last fall; two of them are skiing, and at the moment I am feeling just a little homesick for the life there at Redstone.

Oh, to say thanks to the Foundation and yourself, and have it wired for sound so you would know how much I mean it.

Returning to Redstone from Taliesen, Mechau poured all of his energies into com-pleting the murals for Fort Worth—"The Taking of Sam Bass" and "Texas Rangers." He also put the finishing touches on the small-scale design of "Prairie Fire" for Brownfield.

A letter Mechau wrote to a friend reveals what life in the high country was like for the family during this period, when he was no longer teaching at Colorado Springs Fine Arts Center, but was devoting his entire time to studio work and the practical matters of living:

> Here, in this little town of Redstone, seventy-five hundred feet above sea level, we function—painting and leading a life that is rich with raw experience. We ski, snow-shoe, bring in skins to tan for our own jackets and chaps. We take pack-trips into the high country, follow rodeos and harvest crews, fight forest fires, live and paint.

Despite the satisfying pattern of life, Mechau was aware of "the dangers and pleasure of an ivory tower existence," as he had said in a letter to Henry Moe, and he acknowledged the need for periodic terms of teaching, although there never seemed enough hours in the day for both. At about this time, Oronzio Maldarelli wrote Mechau about an opening in the art department of Columbia University, and urged him to apply.

Although his desire to stay in the West was keen and his wish to develop a working relationship with Frank Lloyd Wright remained strong, Mechau decided it was financially necessary to find a full-time teaching position. He therefore pursued the opening at Columbia University which resulted in his appointment as the head of the Department of Painting and Sculpture in the School of Architecture. The following article about his appointment appeared in the *Glenwood Post* on May 11, 1939:

> He will have his own private studio, furnished by the University for his own work, and a private office. He will have six professors under him—five of whom will be painters and one a sculptor. The family will spend the summers at Redstone and will go to New York with him during the school year.

So the family was off to the city and found an apartment a few blocks from the university. Within three weeks after Mechau's arrival at Columbia, the university arranged for an exhibition of his works.

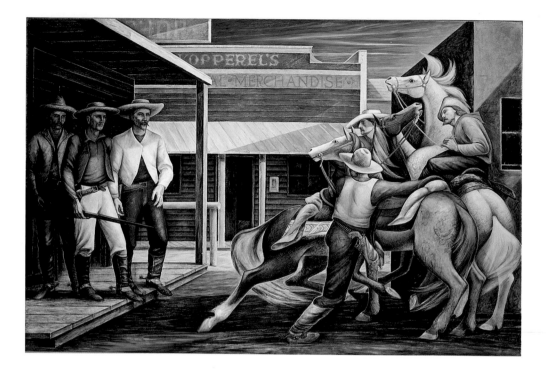

Colorado papers continued to follow Mechau and his career, and the *Rocky Mountain News* provides an interesting vignette of Mechau at work in New York:

> *Photographs of the mountains are the first things you'd see were you to visit Frank Mechau in New York. For Mechau's a Coloradoan and frank to admit that the only thing that keeps him in New York is his job. . . . He has his studio in East Hall and it's full of paint tubes, brushes and unfinished pictures.*
>
> *It's from Denver, in fact, that artist Mechau still draws a quota of students. . . . Everything in his studio suggests a workshop. His desk is half concealed behind a large sketch. In a corner stands an unfinished painting. He combines picture making with architecture because he believes that painting, sculpture and architecture should be an organic functional whole.*

Texas Rangers 1940
Oil on canvas
96 × 141
Eldon B. Mahon U.S. Courthouse
Fort Worth, Texas
U.S. General Services Administration
Fine Arts Collection

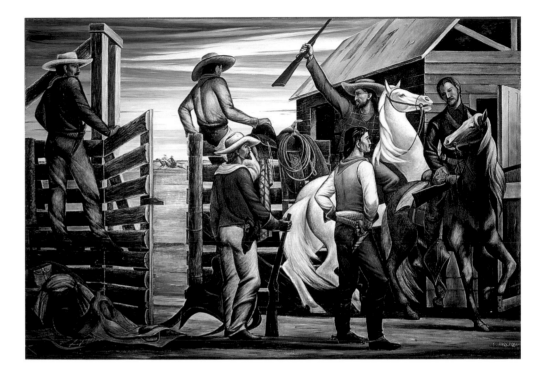

With his students, Mechau is working with what might be called the "artist-in-residence" idea. He takes only specially good ones after an interview, and they do everything—stretching canvas, enlarging sketches, mixing colors.

Mechau wrote a few years later to Margit Varga of *Life* magazine, reaffirming his belief in instruction by apprenticeship:

When I returned to America some ten years ago, my question was the same as other young artists. What was to be our destiny, if any? Would we have the wave of native architecture that would carry painting and sculpture forward as we hoped? Most of us tried sticking our thin cafe roots into native soil. Came the regionalist movement, good

with bad. Then the government mural competitions brightened the horizon. They made it possible for young artists to stay where they lived. Greenwich Village was no longer an essential stop in the formula of becoming an artist. . . .

For the first time in American history there was an opportunity to build an organic type of school, the first principle being the selection of student assistants and giving them actual experience in the painting of murals. With Boardman Robinson and Henry Varnum Poor, I continued along these lines at the Colorado Springs Fine Arts Center, utilizing the ace students as apprentices, later encouraging them to enter government mural competitions.

Mechau working with his students at Redstone's Big Horn Lodge

This approach was very successful for Mechau as well as for his students. In the Dallas competition, six of his students won awards, and five students from the Colorado Springs Fine Arts Center school placed as runners-up in an Amarillo competition. Three of Mechau's students—Ed Chavez, and Ethel and Jenne Magafan, who had worked with him in Denver, Glenwood Springs and at the Fine Arts Center—won several mural commissions in Treasury Department competitions. Furthermore, all three were represented, in their early twenties, in the Museum of Modern Art collection.

Mechau continues his letter to Margit Varga:

"The outstanding example of the apprenticeship plan is Frank Lloyd Wright's Taliesen Fellowship where young would-be builders learn to build by building."

The significance and impact of this approach to teaching and learning is expressed in a letter from Edward Chavez to Paula Mechau in 1978:

I have been mulling over what to say about my relationship with Frank in the old Project days as a student and apprentice. . . . How can one evaluate such an experience? How can I express what it meant to me, an aspiring young artist of eighteen years, naive and innocent and uneducated, fresh out of the beet fields of Eastern Colorado, taken under the wing of the young "Master" Frank Mechau, who had just returned from Paris to his native and beloved Western Slope of the Rocky Mountains?

Mechau with apprentice Edward Chavez

The association with Frank in the following years, 1934 until I went into the Army in 1940, was an experience that I think must be rare these days. A relationship not as student and teacher, but as apprentice and master painter, sharing in the work at hand, not only listening and learning—participating and learning. Active and creative participation not only in the work of "Art," but also in the "art" of living.

I can never forget the days in the Redstone Schoolhouse Atelier working on one or another of Frank's various Treasury Department murals in those wonderfully magical Redstone winters; and later in the evening, before a roaring fireplace, after a shared meal with the Mechau family, discovering Mozart by way of his Concerto in A Major, or the readings aloud—the discussions about Piero della Francesca and Pieter Bruegel. . . . This only begins to suggest what it meant to me to have known Frank Mechau. The effects of this relationship are still directly an important part of my work, and an influence in my life.[7]

Despite the fact that Mechau had a studio of his own at Columbia University, his teaching and administrative responsibilities meant that his own painting pace was considerably reduced. As he put it, "This was rough on production—two or three a year has been my output, most of them sold."

However, the instruction in the Department of Painting and Sculpture was lively and stimulating. The faculty was composed of actively producing artists who were reinforced in their teaching by distinguished visiting critics such as John Marin, Stuart Davis and Buckminster Fuller. The instructors included Oronzio Maldarelli, sculpture; Henry Meloy, drawing; Peppino Mangravite, drawing and painting; Hans Mueller, graphic arts; and George Grosz, watercolor. There was not an academic pedant among them.

Leaving New York City to return to their Redstone home for the summer was a time of joyous freedom for the entire Mechau family. For Mechau himself the life-sustaining quality found along the Crystal River was a kind of spiritual tonic. It was during the summer of 1940 that the writer Kaj Klitgaard was traveling across the United States gathering material for his book, *Through the American Landscape*. In his chapter on Colorado, Klitgaard wrote,

It was, in particular, Frank Mechau I had wanted to encounter, for it was his murals in the Washington, D.C., Post Office that had made me put Colorado on my itinerary in the first place, and on entering his state I had looked around for his long horizontal clouds, his green skies, and his red mountains.

Arrangements were made for Klitgaard to visit the Western Slope but time and other commitments prevented the journey, so the two men never met. However, Klitgaard included several passages from Frank's invitation in his book.

Mechau's directions were written as if the two men were to make the journey together and Klitgaard relates the proposed route in the artist's words:

We should have driven across South Park, a vast beautiful undulating knolled plain buttoned by clumpy cedars, like the hills of Arezzo, placed in an ocean of ochres and

Mt. Sopris rising above the Roaring Fork and Crystal River valleys.

ringed around with snow-capped mountain ranges. . . . At Glenwood, this is Red Mountain! It starts like a hawk sweeping upward from the banks of the Colorado River. The soil is sheer Indian Red from its base, where the old Devereaux ranch sprawls, to its ridges where dark pines march along. I have tried to use this extraordinary mountain in the central panel of the predellas in the Washington, D.C., Post Office; I barely managed to sense it, and will go back to it when I feel big enough to try again.

From the rim of Red Mountain the Flat Tops commence to roll in an unbroken area of sixty miles of crater lakes and virgin forest of pine. Up one of the deep canyons winds a road, a thirty-mile cul-de-sac. There is Redstone on the Crystal River, but nothing has been said or done about this magnificence. . . .

And there above Carbondale surges Mount Sopris, which I tried to use in the "Roundup" you saw at the Art Center.

As we leave the ranching country, we slip between colossal crags of granite, a final gateway just large enough for the car and the river to squeeze through . . . and arrive at . . . a fantastic little town . . . a little Utopia . . . deserted.[8]

In the seclusion of his Redstone studio, Mechau began frequent experiments with the difficult but extremely durable medium of tempera, enjoying the luminous color that could be realized. All of the small-scale designs for the Dallas Post Office competition were executed in tempera and in 1940 one of them, "Stampede," was shown in an exhibition at the Nebraska Art Association in Lincoln.

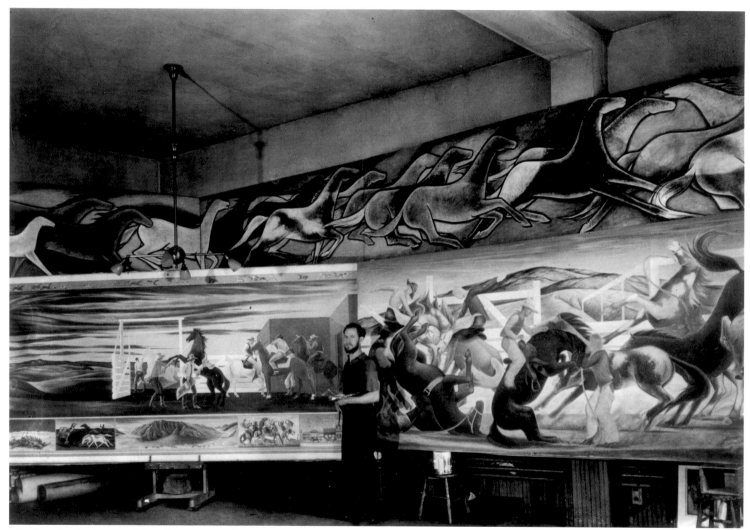

Mechau in Redstone School House studio

That same year another of Mechau's paintings, "Indian Fight #3," a semi-abstraction on loan from the Walker Galleries (with which he had been associated for several years), was shown in the *Cranbrook-Life Exhibition of Contemporary American Painting*. The roster of exhibited painters was a familiar one for that period, and of the sixty exhibitors, thirteen were in their thirties. Archibald MacLeish, who wrote the foreword to the catalogue, emphasized the fact that man and the place must find a unity before a distinctive art can be produced. His final paragraph echoed some of Mechau's convictions:

> That this American art is a great art, as such things go, is not asserted. Its masters are not masters of the stature of Piero della Francesca. But that it is an American art, an art truly American from which a great American art can grow, no one will seriously deny. If it is true, as it is true, that the art of painting is an art which must inhabit the earth, and if it is true, as it always has been true, that the beginning of a new art of painting is a new understanding of the relation of the earth and men, then this is the beginning of a new art of painting, because an understanding has been found. For the first time, we in this country have seen ourselves against the continent in which we live. We have seen that we belong here. . . . And we know now what the word America could mean.

In 1942 Mechau completed a tempera painting titled "Saturday P.M.," one of his favorite works which he described as "the little gal in the vermillion dress floating by the saloon." The painting made its exhibition debut in October in the *53rd Annual Exhibition of American Paintings and Sculpture* at the Art Institute of Chicago. It traveled to the 1943 Carnegie exhibition, *Painting in the United States*, and in March 1944 it was included in an exhibition in Lincoln, Nebraska. Frederick Sweet of the Art Institute of Chicago, on viewing the show, was quoted in the *Lincoln Sunday Journal Star*:

> Much in Frank Mechau's "Saturday P.M." is a successful transference of mural technique to easel painting and one of the good things to come out of the confused period of the thirties.

74

Many of the tempera paintings had been initiated and realized at the Redstone home in the summer of 1942, making it difficult to think of returning to New York. Keenly aware of this, Paula Mechau suggested that she and the children remain in Redstone for the winter. The money saved on rent alone would make it possible for Mechau to take a leave of absence from Columbia and devote the following year to painting. After some urging he consented. Mechau was reunited with his family during the Christmas holiday, but all too soon the vacation ended and he returned to Columbia, finding little free time for painting.

In December 1942 Mechau submitted "Horses at Night" in an open competition sponsored by the Metropolitan Museum for an exhibition titled *Artists for Victory*. There were 8,000 entries from which 532 works were selected and Mechau's "Horses at Night" was one of them. It was illustrated in the catalogue and commented on by Manny Farber who reviewed the painting section of the exhibition for the December issue of *Magazine of Art*:

> *Frank Mechau's hard surfaced painting of wild horses in Colorado has the unrelaxed strength of a bas-relief with the necessary color to make an exciting work. It has an intentional dry hardness in its color and in the conception of the stylized horses that gives it a consistent violence.*
>
> *The only deviation from bareness is in the varying size and nature of the horses, and in the somewhat too sudden curving of their flight at the right side of the picture. The individuality of the picture is in the forms themselves and their juxtaposition. . . . It has primitive finality and power.*

Further recognition of Mechau's stature as one of the outstanding American painters came in 1943 when he was first included in *Who's Who*. He was one of the youngest artists to be so recognized.

FOUR

Such an Elemental Experience

I would like to recreate some part of such an elemental experience,
but it seems so titanic and complex a problem
of movement, light and sound . . .

In spring 1943, while still teaching at Columbia, Mechau received a letter from George Biddle (who had been one of the major proponents of the Depression art projects) asking him to participate in the documentation of the U.S. Armed Forces in World War II. The letter informed him that he had been recommended by the War Department Advisory Board as one of few outstanding American artists to go into the war theater to obtain a graphic record of the war. The areas to be documented included the Caribbean and South America, West Africa, England, Iceland, Northeast Africa, the Near East, India, Burma, and China. As one member of the committee, Henry Poor, said, "The United States must take the lead and find some way of getting from our finest artists and writers the things they alone can give—a deeply, passionately felt, but profoundly reflective interpretation of the spirit and essence of war."

John Steinbeck, another member of the committee, wrote:

A total war would require the use not only of the material resources of the nation but also the spiritual and psychological participation of the whole people. And the only psychic communication we have is through the arts.

In this war, there will be a greater amount than ever before of written, photographic, and pictorial data. Our Committee expects you always to be more than a news

Lone Patrol 1943–44
Oil and ink on canvas
26 1/4 × 41
Courtesy of the Army Art Collection
U.S. Center of Military History

gatherer. The importance of what you have to say for the historian of the future will be the impact of the war on you, as an artist, as a human being.

One has in mind Goya's "Horrors of War," Orozco's drawings of the Mexican Revolution, the lithographs of Steinlen, Forain, and Naudin, . . . the sketches and battle scenes of Gericault, Baron Gros and Delacroix; or in another medium the imperishable war writings of Tolstoy, Eric Remarque, Hemingway, and T. E. Lawrence.

Mechau was assigned to the Caribbean and to Panama as the head of a four-artist unit which included Reginald Marsh, Alexander Brook and Bernard Perlin. He left on June 2, 1943, traveling by cargo and amphibious planes to Cuba, Panama and several Pacific bases, undergoing forced landings four times during violent tropical storms.

His log begins June 2 in Miami:

Arrived in Miami . . . while waiting to see the commanding officer, I looked over the city's low rooftops. The place is smooth as an ironing board and twice as hot. Would sure hate to live in such dull terrain. How positive and architectural a mountain is— it takes form to give space meaning. . . .

Balboa, Panama . . . have flown back and forth over the Isthmus at a low altitude. Already I feel I have enough raw stuff to swing into action. . . .

A tropical storm. The first round began brewing in the late afternoon. Dark cumulus clouds developed from the dragonesque vapors that steamed from the jungle valleys. The sky darkened and glowered from gray to a purplish, apoplectic cast. When it reached its saturation point of glowering color content, the heavens began to emit sheet lightning which wasn't sufficiently dramatic, so bolts of lightning and thunder shook the Atlantic and the rain fell in stinging torrents.

Far over on the Pacific side, past the little Isle of Taboga, where Paul Gauguin first lived, the sun shone brilliantly, the sea spread out into vast space with little islands marching one after another into infinity and nothingness, like a Surrealist's dream. But long, dark horizontal shadows banded the sprawling ocean expanse, presaging the storm to be.

It came! The light went out as though a fuse had been blown out in God's powerhouse. The wet stuff became a furious monster striking from all quarters with a malicious vengeance. The beautiful trees and tall, elegant grass rocked and reeled like a punch-drunk boxer trying to stay erect but weaving wildly about to escape the knockout blow. The sheets of water hissed down with merciless force, the air was filled with the green smell of chlorophyll, as though the plant world was suffering a cataclysmic hemorrhage. Our part of the universe had suffered a convulsion for hundreds of miles around the Canal. How many young boys in planes were lost that afternoon and night is of course a military secret. The paper next morning was filled with news of the hurricane's civilian toll and property destruction. Sure would like to recreate some part of such an elemental experience, but it seems so titanic and complex a problem of movement, light and sound that no solution has come to me as yet. Guess it will have to simmer inside until something gestates.

The journey was demanding and subject to the exigencies of the war operations. Mechau reports that he returned to Panama "after a 10,000 mile spree" and that soon

Mechau with local residents near Quito, Ecuador, 1943

With young Panamanian, 1943

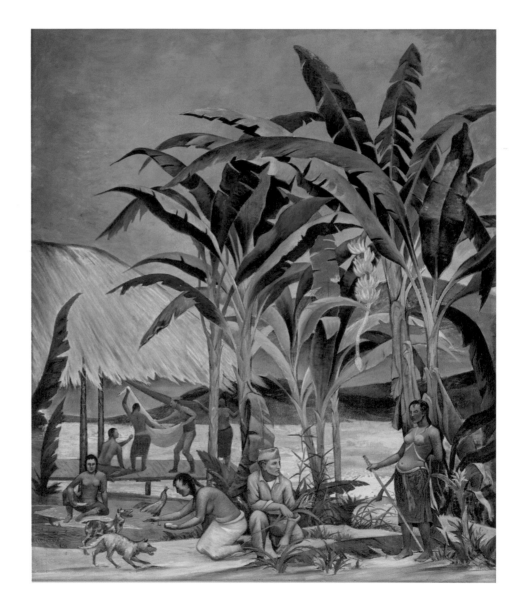

Darien Indians, Panama 1943–44
Oil and ink on canvas
32 1/8 × 27
Courtesy of the Army Art Collection
U.S. Center of Military History

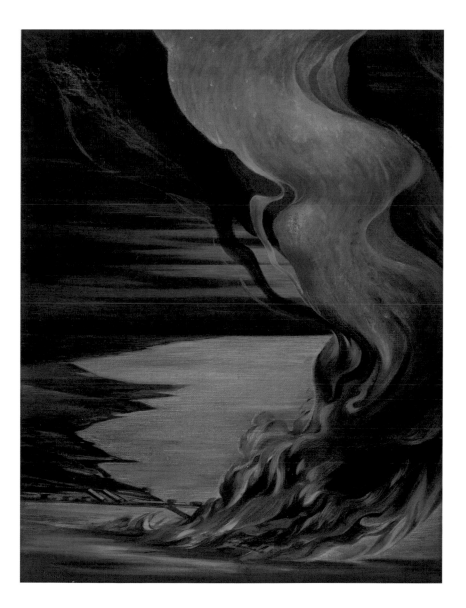

Early Morning Bombing *1943–44*
Oil on canvas
30 1/8 × 23
Courtesy of the Army Art Collection
U.S. Center of Military History

81

afterwards he set out for Ecuador, encountering storms which forced them back twice. On the third attempt, the young captain of the plane had all the baggage lashed down. "The ship staggered and wallowed in the heavy sky where we hung helpless in space," reports Mechau, "and the motors began to choke spasmodically like asthmatic monsters." Finally, the pilot turned toward Colombia and landed in an emergency field at Cali. The next stop was Guatemala and then the Antilles.

Mechau's imagination was filled with all kinds of painting motifs and his briefcase was bulging with sketches, notes and photos, but another excursion was planned despite his impatience to get back to his studio to work on these projected paintings. The last part of his journey involved a perilous flight over the Andes.

> Up we climbed heading arrow-like for the Andes; the valley leading to Quito was cloud-packed and guarded well on the other side by formidable snow peaks. We all held oxygen masks to our faces as we climbed to 17,000 feet plus. It was plenty scary, as we sometimes hit a hole in the clouds and the plane's wheels seemed almost to touch the sides of the rocky slopes.
>
> We came out over the wide and richly cultivated valley leading to Quito. It was vast, long and wide and every square mile of it was a crazy quilt pattern of farms and haciendas that went up the hillsides to an altitude where nothing could grow in the United States, but being on the Equator offered agricultural miracles. What magnificent farms, tattooed with varied shaped rectangles and ferny-looking groves of eucalyptus. Quito sparkled in the sun—plazas abound with old Spanish churches and roads winding around precipitous hills like a super-Mantegna background.

When the time came to depart from Quito, Mechau confessed that he hated to leave because the city was the most interesting he had ever visited and the surrounding environment spectacular.

Returning to Panama, the flight went well until they were about an hour out of San Jose in Costa Rica "where we hit another accursed storm which drove us down after

floundering around into a pasture filled with horses and cows." The big plane was literally stuck in the mud. The rescue resources of the small town were nineteen sloe-eyed, slow-gaited oxen and 150 schoolchildren. It took two attempts and necessitated a stay overnight, so the town's people killed a cow and planned a dance in the evening for their unexpected visitors.

One of the most exciting episodes of the trip was a forced landing among the Indians on one of the San Blas Islands; it was the inspiration for several paintings. Following is Mechau's description of the experience:

> *Maj. Huie, the photographer, and I buckled ourselves into a four-seater hydroplane, as there would be no landing field where we were going. We looked forward, with a measure of excitement, to putting down on the sea, as none of us had been in a sea-plane before.*
>
> *The ride over the series of idyllic-looking atolls was enchanting. When we reached the island we circled it several times looking for a calm strip of water. Suddenly it became alive with Indians, and from the mainland a stream of cayucas (dugouts) streaked, with their occupants rowing like mad, for their island village. Hundreds of the small, flat canoes filled the waterways. We circled and came down very low, but still they didn't make room for our landing. We were forced to land in open water which we struck with a terrific crash. . . . The plane nearly slipped over on its back, and the tail was badly damaged. . . . We were soon surrounded by laughing Indians. . . . They took us ashore to their Chief who welcomed us and invited us to look around the island.*

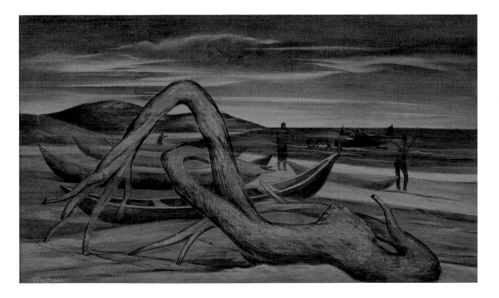

The following day, a crew arrived to repair the damaged plane and soon

afterward the group returned to Panama. Mechau notes in his journal just before taking off for home:

My last night in Panama the new carrier, Yorktown, came in by moonlight and was an impressive sight, I'll never forget. . . . What a truly beautiful piece of architecture in a cold, abstract way. The super-structure on one side of the ship looked like a colossal stage-set of interlocking geometrical shapes. However, nothing so innocent as puristic sculpture. This beauty was designed to deal out death. . . .

The next day I left Panama. The magic of air transportation whisked me from a strange tropical world quickly across the Central American countries. We crossed the Rio Grande and in no time at all I was home in Colorado.

Angry San Blas Girl 1943–44
Oil and ink on canvas
32 1/8 × 39
Courtesy of the Army Art Collection
U.S. Center of Military History

In Glenwood Springs, Mechau heard that one of the young pilots he had traveled with had been killed. "The news depressed me terribly, as I recalled the splendid boys on that crew," he wrote. "They were, no doubt, victims of a tropical storm. The horror and desperation of a plane going down in a merciless ocean was terrifyingly near to me. . . ."

One of the most dynamic paintings to emerge from this experience was "Death by Water," and Mechau concludes his log of the journey with these words: "I am painting

Death by Water 1943–44
Oil on canvas
26 1/2 × 42
Courtesy of the Army Art Collection
U.S. Center of Military History

now, have seven compositions moving along, but the one that fascinates me most is a sea piece, the tail of a flying fortress is slipping out of sight, being consumed by monstrous waves."

Shortly after his return home, Mechau received the startling news from Washington, D.C., that the Federal appropriations for the War Unit series had been canceled. But he discovered *Life* magazine had offered employment to all civilian artists who held War Department contracts. Mechau's reaction was described in a letter to Margit Varga:

Coconut Grove 1943–44
Dry brush oil on canvas
35 5/8 × 27
Courtesy of the Army Art Collection
U.S. Center of Military History

Returning to Colorado from an exciting trip, crammed with multiple unborn paintings, to learn that Congress had killed the War Art Unit, was sure a shock, so you can imagine how your telephone call registered.

I have spent a full week in the studio washing and ironing out notes and ideas to find that there are some twenty-two themes crying out for existence. Gradually I have narrowed the number down to ten and am working on layout, hoping that the themes which dictate shapes may be organized so as to relate to each other when reproduced. In a few weeks I should like to show you Kodachromes and tentative layouts for the pictures in process, so that I may have a definite goal to shoot for.

Mechau once again devoted himself full-time to his painting. The thought of returning to academic disciplines and routines seemed less and less attractive. On August 2, 1943, he wrote to the Dean of the School of Architecture at Columbia, asking for a leave of absence which he was later granted. In fact, this was to be his severance with the academic world.

FIVE

⤢

The Most Important Creative Years

These next ten years are the most important creative years of my life. . . .
Just how we can achieve financial immunity without
compromising art production, only the future can tell.

Freed from teaching, Mechau looked forward to a full year of painting in his Redstone studio—first on the agenda, completion of the *Life* assignment. Shortly after he returned, Henry Moe wrote a word of caution and advice:

> *There was reproduced in* The New York Times, *a couple weeks ago, a photograph of your "The Last of the Wild Horses," and looking at that picture I was moved to wonder whether or not the painting you are going to do, based upon your travels, will be one tenth so important to do as your painting of the country you really know. . . .*
>
> *What I am saying very definitely is that it is inconceivable to me that you can do the quality of work with your Pacific material that you can do with your own baili-wick. And quality is the all-important thing in painting as well as in most other things. Without, I hope, cramping your style too much by this kind of talk, I do hope you will take it seriously and during the year at least paint something on the themes you handle so well.*

Frank replied:

> *There was a swell letter from you waiting for me when I returned, and believe me I sure do appreciate it, for it brings the ever-present pitfall into the open. Compromise*

Tom Kenney Comes Home 1944
Tempera on masonite
30 3/4 × 47 1/2
Robert Lewis
Denver, Colorado

89

is on every side, cleverly marked with a false front. When Government murals petered out about four years ago we were forced out of our little stake into accepting the berth at Columbia.

You said, "Frank, will you be able to continue your painting?" I can only hope so, I said, and hoping is about all I did. Two paintings a year was my production—and they weren't right, for my way of living was wrong. When I saw the reproduction of "The Last of the Wild Horses " in the Times, *a feeling akin to the one you must have had—a singing sensation—I said to myself, you hit pay dirt there boy, what about it, can you do it again?*

So I went to my studio to look me over. I looked instead at Mt. Sopris rushing spang upward out of the earth into a cloud flying apart, ignited by the sun against a cold winter sky. I love this country so much that I rarely indulge in the conceit of doubting myself—this place can carry me without effort.

Hank, I will paint much, much better things than I have when our liberty is gained—and it won't be long. Our diggings here will soon be paid off—(two years)— then I think I will be able to make a living for the family if I have to go from ranch to ranch doing portraits of the farmer's wife, his team, or his prize bull—just so I can stay here and paint.

So I figure Columbia and Life *are interludes and detours with hurdles and snares. I have given them the best that I can with half my heart.*

In 1945, Mechau produced some of his finest paintings. Settled in his Redstone home surrounded by books and by the love of his family, he began painting "Children's Hour" and "Dorik and His Colt." The latter painting was shown in the 1945 Colorado Springs Fine Arts Center annual exhibition titled *Paintings by Artists West of the Mississippi.* His painting, "Autumn Roundup," with its magnificent sweep of mountain valley and mountain peaks—a background for cowboys rounding up cattle—was exhibited in the 1945 Carnegie show, *Paintings of the United States.*

In Mechau's compositions of this period, friends and neighbors were often the subject material, and "Tom Kenney Comes Home" falls into this category. First shown at the

Art Institute of Chicago in 1945, the painting was acquired for the *Encyclopedia Britannica* collection. The catalogue published by the *Encyclopedia Britannica* contained a reproduction of each artist's work, together with a brief biographical résumé, a photographic portrait of the artist, and a personal statement about the work selected. Of the "Tom Kenney" painting Mechau wrote:

> *From the subjective angle, one man represents the multitude of men who took over the West's toughest job, the cowboy prospector. They knew no home, and rarely stayed in one place long enough to make friends. For the few who accidentally "struck it rich" to become political powers and builders of ostentatious mansions, there are thousands still working on ranches and doggedly prospecting high ranges, eking out an existence—a wonderful group of forgotten men of Lincolnesque character.*

For Mechau these rugged characters were not mere subjects; they were friends and neighbors—companions on the trail, at the rodeos, and in the labors of the seasons. He delighted in their rough-and-ready manner, and he cherished their propensity for the tall tale. In December 1946, a tale written by Mechau accompanied a small reproduction of "Tom Kenney Comes Home" in *Esquire* magazine. Titled "The Helliferocious Fight of Tom Kenney," the article reflects much of the warm and intimate relationship Mechau had with the high-country folk of Colorado. In the article, Mechau wrote:

> *The other day I rode six miles down our canyon to give Tom Kenney a photograph of a painting I had done called "Tom Kenney Comes Home." . . . You should see the cabin perched on a rock above the Crystal River with crags soaring upwards a sheer 3,000 feet. There Tom lives and works a mine. It was evening, so Tom was in. Knowing him for the silent man he was I toted along a jug to oil his lantern jaw; without such lubrication all you can usually get out of him is a grunt.*
> *I handed him a print of his homecoming; after a searching look, he finally said, "That's purty good, Frank." And that was all he said.*

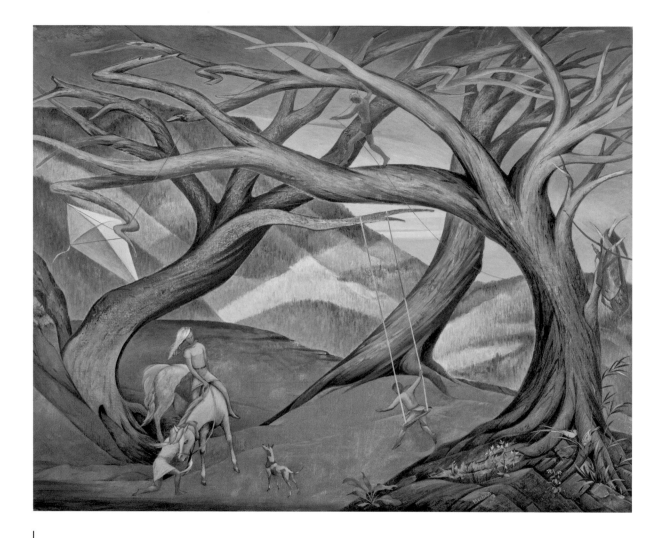

Children's Hour 1945
Oil on canvas
32 × 40
Paula Mechau Estate
Palisade, Colorado

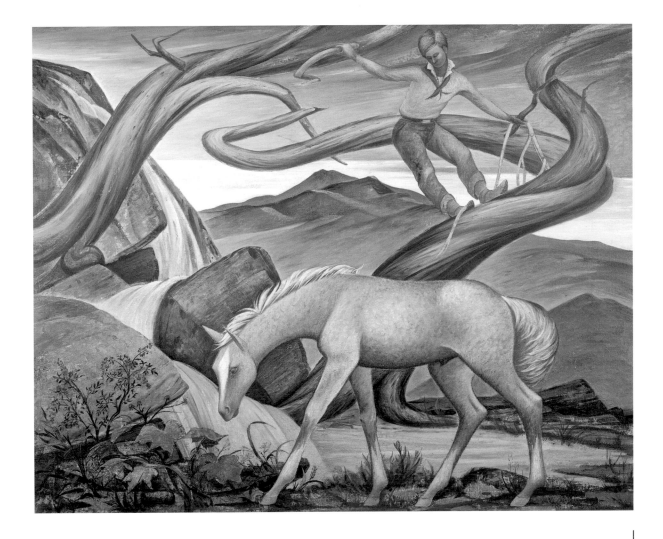

Dorik and His Colt 1944
Oil on canvas
32 × 39 3/8
Shirley Gustafson
Denver, Colorado

Riding home, some of the incredible tales of Kenney slipped through my mind. He was top bronco peeler in Colorado the past forty years; quiet, even gentle, he became famous as a scrapper.

One time Tom was in an Aspen bar quietly humming "Darlin' Cory" to himself as he was taking on his Saturday night glow. Into the saloon on horseback rode Yavapi Pete acussin' and ahollerin'. Tom paid no particular attention until Pete's horse stepped on his foot. Then he said, "Get that damn hoss offa my foot." Pete bawled back, "What in hell you doin' in here afoot anyhow?" And Tom just stood there, thinking about it and showing no emotion.

Pete, being an Arizona screamer, yelled out his brags in a voice that echoed like the bottom of a barrel and could be heard for miles around. "I'm a riproarin' fist slinger. I kin whip any damn man that ever crossed the Rockies—I got six rows of arms, nine rows of teeth, twelve rows of laigs and holes punched for more—I can outfight, outbite, outbrag, and outkick any man alive."

Then Pete made a spectacular leap from his horse to the floor, turned a front flip onto the bar in a neat handstand. He ordered eighteen shot glasses to be lined up with 100 proof whiskey and drank them all upside down by taking the glass in his mouth and giving his head an upward flip.

When he had downed the eighteen glasses, standing on the bar, legs apart, he challenged all comers, yelling, "I'm spilin' for a good fight, ain't had one in three days— I'll be fly-blowed by mornin' if some of you limp yokels don't give me a little sweat. Look at this chest if you dare to with the naked eye. I'm well nigh all haired over. Stand back, you shy plants, let a real man throw out his chest, and give it plenty of room for I'm about to pull your petals off; bow yore heads and scatter . . . calamity's acomin'."

By this time Tom Kenney was interested enough to look up from his drink and give attention to Yavapi Pete. Everyone listened as Kenney said real quiet-like, "Pete, I don't want no trouble with you, but if you don't get yore damn hoss offa my foot, I'll snatch you balt-headed and spit tobaccy juice where the hair was."

With a squeal of ecstatic delight, Yavapi Pete yelled in his most ear-splitting voice, "The fight's on. Roll up yore pants for you'll soon be standin' ankle deep in blood and gore."

Barroom Brawl c. 1938
Tempera on masonite
6 1/2 × 17 1/2
Mr. and Mrs. Morgan Smith
Santa Fe, New Mexico

Tom, cool, lithe, and limber as a whip handle, let Pete have a terrific socdologer that turned his liver and lights to jelly. But Pete was a real scrounger; he broke three of Tom's ribs with a left jab and knocked out five teeth with a right hook. But Tom kept acomin catlike and fast. They went to the floor, Pete on top with a bitehold on Tom's thumb; "Go on, gnaw it off," says Tom. "You ain't hurtin' nawthin' and besides I've got another on t'other hand."

It was the most helliferocious fight ever seen in the West. Tom and Pete fought each other standing and they fought each other sitting in chairs. They fought front to front, back to back, back to front, and vice versa. There was no way they didn't fight and it was a terrifying and wonderful thing to witness. They fought each other and they cussed each other and it was a sight to behold and a sound to hear.

They fought all Saturday night, only stopping for drinks and breakfast Sunday morning. They stopped for lunch Sunday noon and then fought on most all Sunday until their eyes swoll shut and they couldn't find each other. So the fight came to an end, because there wasn't any reason to keep it going.

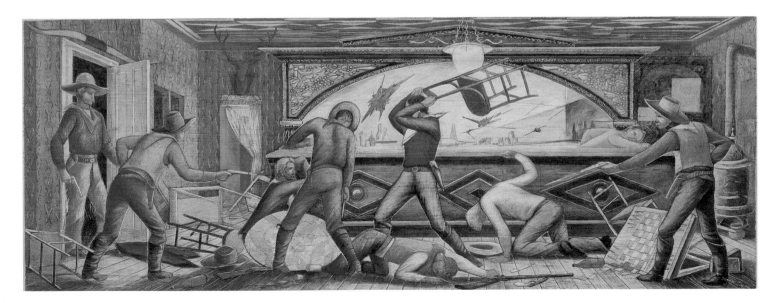

I asked Tom about the riproarious scrap; he told me that the story as told, while not all fact, was true. Tom said, "I got to know Pete real well after that fight. He was a swell guy just out lookin' for a little fun. But do you know what they did to him? They ran him out of Leadville 'cause they thought he was a sissy."[9]

In fall 1944 the Mechaus sold the Firehouse and traded their home for one in which John Cleveland Osgood had lived with his first wife while his mansion was under construction. The Mechaus moved into their new home the following spring. In a letter to Verona Burkhard, a former student of Mechau's at Columbia and a long-time friend of the family, the new location is described:

Mechau and wife Paula listening to their children sing, 1943

The place is called the Crystal River Ranch House, and you may recall how it perches on a side hill with Sopris to the north and Chair Mountain to the south. The Crystal River crashed through the valley with a titanic roar—leaving a curvilinear pond in the back of the barns. In the early morning and evening the shadows rush down the steep inclines across the pastures dotted with 125 pure-bred white faces and an assortment of horses. The ranch is a busy place, and we are all fascinated with the new life of the place.

And in a letter addressed to Mildred Seacrest, another student, Mechau outlines something of his life and painting in their new home:

We have paid off the mortgage on a new-old homestead above Redstone a couple of miles. I worked like hell shingling the roof, and prettying up the sewer system and such. We have a much more comfortable home with an efficient little studio to boot. . . .

So pictures (I think better ones) are emerging, some dozen and a half compositions coming along—pictures dealing in a semi-abstract manner of our lives and loves hereabouts—the canyons with their

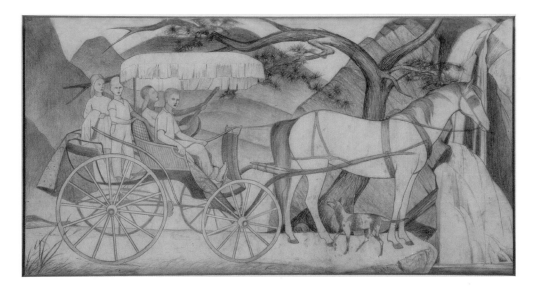

eroded water-kist and wind-carved forms harboring unpredictable colors. The stately ponderosa pines with hunted deer fleeing in the early morning light. The children all singing aboard a surrey with a white pony before rockbound waterfalls sealed in with mountain profiles.

"Childhood and Early Sorrow"—the burial of their little black and white dog, Pinta, the four children over the dog and the scooped hole, the little mustard jar, containing the love poems we all wrote to bury with her—only we would know it. For the so-called inorganic dominates. The picture is 98% landscape, but the 2% motivates the mystery—the heart tick is precious. And so on and on, which no doubt sounds us literary as hell, which I don't mind a particle for I hew to the Chinese line on the principle of motivation or vehicle. I believe the mainspring should be deeply felt, the plastic means is to achieve that end subtly in terms of color, line and other such— veri-unmodern eh?

Of course I think well of Picasso and Matisse, but I rue the fashionable tizzy thereof. Poor devils, as fine as they are they were born to a vacuum—their contribution has been made to those of us who are aware of their worth. Your local propaganda is a lost

Early Sorrow 1945
Pencil on paper
14 3/4 × 12 3/4
Paula Mechau Estate
Palisade, Colorado

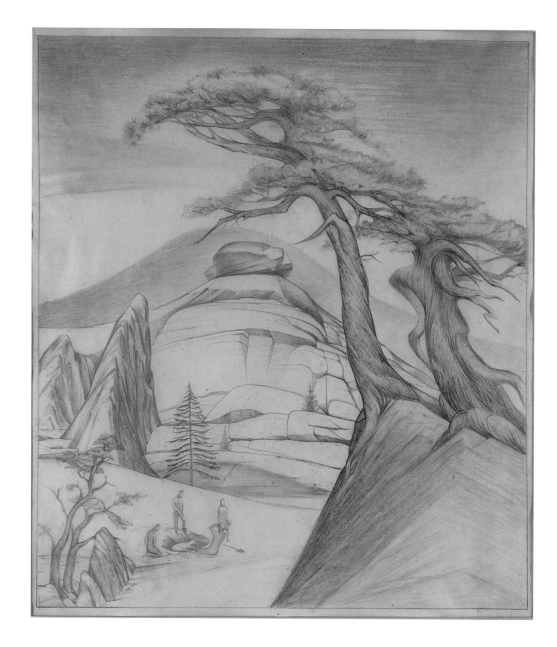

gesture fostering the dealer's interests—high prices and cultural snobbery. The issue you fight for in Lincoln is 30 years late—the same way Impressionism came to the Garden of the Gods in Colorado Springs, 30 years later than it did to Monet's lily ponds.

What I am trying to say is that Gertrude Stein, Pablo Picasso, Matisse and other "moderns" aren't so significant in themselves, but they are sensitive historians turning the tumblers in the vault of history for our benefit.

So if we must educate others, I think they would point—Stein say to Trollope, Picasso in a recent phase (his lingeringest I believe) to Catalonian art, Matisse to the Persians. You know my love for Eliot, so you won't doubt my sincerity when I say they are "half men and hollow men," fulfilling the destiny of a dying continent, hating life and retreating from it. Certainly no one can blame them, but we, I believe, are green enough and young enough to think that life is worth living and worth saying something about in a communicable fashion.

That isn't very well-stated, but it's so damned cold, eighteen degrees below zero this morning, and I'm more prone to fidget than to think or rather feel. Thinking is something I always ask Paula to do for me. . . . Alvin Foote came up to visit yesterday; he and Paula are sitting with Spinoza among the breakfast dishes while I write.

In the summer of that year Frank Mechau was engaged in research for his last commission, four paintings for the Standard Oil Company of New Jersey. He was one of sixteen American artists selected to document the contribution of oil to the American war effort. Mechau was then represented by the Associated American Artists Gallery in New York City and Reeves Lewenthal, its director, selected the artists for the Standard Oil commission. Mechau did his research in Wyoming and Montana and upon returning to Redstone wrote to Lewenthal:

I have boiled down about a dozen ideograms into four good compositions. Number 1 might be called the hazard of trucking oil. A truck is burning fiercely, sending up columns of brown smoke at the base of a rolling hill. In the background

are patterns of strip farming going back into deep, deep Wyoming space. At the left, in the distance, can be seen an oil field. Going into Elk Basin I saw evidence of one such crackup, which fortunately didn't catch on fire, but the immediate landscape was drenched with crude oil. I thought at first I might do the bridge, trees, rocks and flowers covered with the brown, black oil—but it was too fantastic, even humorous, a little too surrealist for me, so I settled for the more dramatic blaze. I saw another wreck out of Cutbank where four people were burned to death. Trucking the crude oil or refined stuff is a risky job. Think I've happened on a dramatic theme here.

No. 2—At Elk Basin I found that the men had a pet eagle with which they spent leisure time, so the eagle predominates in the composition, with the rocky struc-

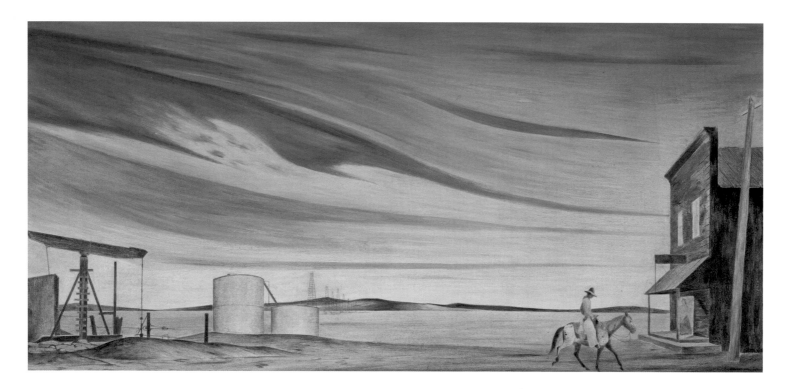

ture of a typical hillside, crowned by a derrick, tank and other accoutrements. In the background is Beartooth Range. No. 3 is an effort to tap some of the vastness of the Montana plateau under which the reservoirs of oil are cached. Here miniscule men work in a world dominated by sky. About three fourths of this design is sky—the strip of earth has been punctured by the drillers with their tiny derricks, or so they seem even though they are 126 feet high. Beyond them the prairies stretch like a rubber band towards the snowcapped mountains in the infinite distance. On the right side is a wood two-story false front building that the highway as well as the machine age has bypassed. There earthy people go on day after day, adding work to work in an arduous effort to extract a living.

The response from Lewenthal was one of indignation and shock:

> I have read your descriptions for the pictures you intend to do and the one of the truck burning fiercely in the background will not do at all! I read it to one of the men over at Standard Oil and he hit the ceiling and said not to waste your time. An oil truck burning may represent a hazard of the oil industry but it is certainly not anything that should be portrayed. It will be as out of place in the project as a sore thumb . . . so don't do it. It will not be acceptable.
>
> Your No. 2 picture sounds all right except the predominating eagle worries me. Your story is supposed to be "oil" and the oil country. Certainly as incidental material such depictions will be acceptable, but it seems to me, Frank, that you have got to keep the main theme very much in mind.
>
> Your No. 3 picture sounds like a landscape rather than a documentary record of the oil industry. To devote three-quarters of your design to sky just doesn't strike me that you are putting the spotlight on the oil industry.
>
> After all, Frank, the deal called for documentary pictures of the work that is being done by Standard in the oil fields and I certainly can't see your filling the bill with the paintings you describe. I am plenty worried and I would like to have some assurance from you that you understand what you were sent out to get. . . .

Mechau , in his reply, explains the reasons for selecting the themes:

Regarding the truck burning, I'm sorry it's a poor theme, but it makes a hell of a good picture. . . . The men to whom I talked thought it was a good idea.

About #2—"Pet Eagle of Elk Basin"—I believe you'll like it. It presents the geologic structure of the region with its derricks. The pet eagle's form is composed against a blank arid hillside. It lends scale and dignity and also acts as an eye catcher, drawing attention to the derricks.

No. 3 may sound like a landscape, but it's my own fault if I fooled around verbalizing, which obviously has confused the issue. What I had in mind was the sort of dramatic socko engendered by the spatial framing of oil activity—see the enclosed photos, one of which got a double page spread in the Lamp *[an oil publication}. They speak for themselves!*

You criticize me for using a composition with three-fourths sky. Here are two good photo examples with more sky than I used. What would they be if they were close-ups of tankers—they might be on a siding in New Jersey. But set in a frame of sky and earth, the oil motif is presented like a jewel.

In haste I said that the oil activity in this composition is portrayed in a reasonable scale. Unlike the photos there are pumps, storage tanks, and an oil field stretching to the mountains in the distance. . . . I'm sorry if I've worried you, but I believe I will turn in four pictures that will be a credit to the project.

Talks with Roy Stryker of Standard Oil led me away from the machinery angle toward the human aspect of oil activity. He said, "Please don't do what the camera can do. If I see another painting of an oil derrick I'll gag. We don't want you artists to duplicate what the camera has done. Try to show some part of the change wrought upon man and the landscape by oil."

Reeves, I want to do a darn good job, the best that I possibly can. Paintings having to do with oil and its background; a sense of the mystery and drama that belong there as much as the obvious machinery. I think I can project some of this poetic spirit and still give you the nuts and bolts in their proper places.

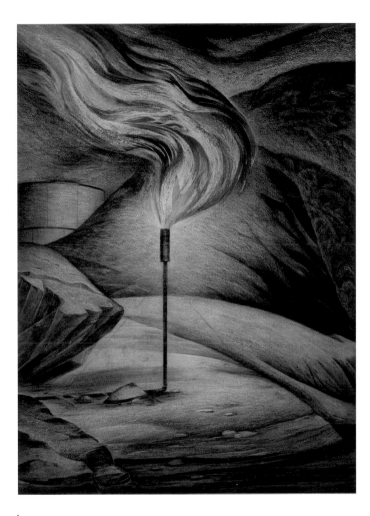

Gas Flares, Elk Basin, Wyoming 1945
Egg tempera on masonite
35 3/4 × 26
Gift of Standard Oil Company (New Jersey)
© Philbrook Museum of Art, Inc.,
Tulsa Oklahoma

Mechau sent a copy to Roy Stryker who responded, *"Your letters are always refreshing. . . . I particularly enjoyed your comments to Reeves."*

Except for the oil truck burning, Mechau made no changes in the subjects he used in his compositions for Standard Oil. His four paintings were included in an exhibition titled *Oil, 1940–1945*, presented at the Associated American Artists Galleries in New York in January 1946.

Mechau's confidence in the poetic integrity of his paintings was justified. All four were acquired by important collections. "Oil and the Old West" and "Gas Flares" went to the Philbrook Art Center in Tulsa, Oklahoma; "Pet Eagle at Elk Basin" was acquired by the Massachusetts Institute of Technology and "Burning the Waste Oil" by David Shepard of Standard Oil Company.

In January 1946, just two months before his death, Mechau wrote from Redstone to his old friend, Jack Juhan:

I know you have been fighting a war, but so have I and mine is a full-time affair: no weekends, no armistice between wars—and from where I sit in this mountain holdout there is a good chance that the results of my personal war might have a more lasting effect than yours. I don't mean just me, myself, but the creative impulse that seems to take such a beating in an industrialized world. But perhaps the blind alley of technocracy will lead us back to more spiritual meadows after the savage peaks of materialistic barbarism. . . .

We are alone, and the winter is hard and long. This is a pivotal point in our lives. We have run out of funds completely. Each mail day brings us hope of a sale to clear another few months for painting's sake. My production dropped to two a year all the years I was at Columbia, and I don't have many pictures working for us. . . .

These next ten years are the most important creative years of my life, all-important to me, and I humbly hope enriching to American art. Just how we can achieve financial immunity without compromising art production only the future can tell. I can sell out for family comfort's sake by teaching at any time, but we will fight it off as long as we possibly can. . . .

In the meantime one quasi-solution has occurred. Anne Downs, an old friend from Denver, dropped in on us by surprise a week ago. When we were in Denver she had invited about fifty people interested in folklore and music to hear the children and Paula sing, and she told us that it was the talk of the season. She would like to arrange three singfests at the homes of friends in Colorado Springs, Denver and Greeley—tickets to be sold at $1.50 each and have about seventy-five people at each concert. Paula and the children were mighty thrilled, and it will not alone be fun but a source of a small sum to tide us over a few more weeks. Something bigger might come out of it. . . .

The children are a source of supreme happiness. They are developing beautifully mentally and physically with their books, recordings, skis and toboggan.

Vanni, now thirteen, is at home this year spending the mornings reading literature and history—afternoons drawing and painting.

The Mechaus were all together in their wonderful home in Redstone. Frank was painting, Paula and the children were learning more folk songs and ballads to add to their repertoire. After dinner the family would gather around a cheerful fire in the fireplace and Paula would read aloud. Money was scarce, but life was rich.

Mechau wrote to his friend, Howard Bell:

The things I'm producing are worth money—quite a hellofalot—not now, but eventually. You've seen the prices that Cézanne, Van Gogh, Gauguin, Modigliani, etc., paintings brought—$30,000 to $75,000 for canvases that could have been purchased for darn little a very short while ago. I don't mean to be griping overmuch. I have had "breaks" and will have them again.

Watering the Horse Herd 1936
Oil on panel
4 1/2 × 20 1/4
Duna and Jack Stephens
Palisade, Colorado

Our present predicament is the net result of five years of school teaching and darn little creative painting. Finally I have gotten back to my own paintings, and am hard at them with a half dozen near completion and another dozen maturing into compositions. The pictures will eventually find harbor. It's the meantime hazard we are stepping over. . . .

Security—I wonder what Webster's dictionary says—"freedom from apprehension." In that sense, we have semi-security, for we fear not. Although we are kicked around by the elements, it's bound to toughen us, and also we have the friendships that have stood by us. We believe we are winning and will continue to win somewhat from life before the inevitable beating is sustained.

Just a few weeks after these letters, the six Mechaus set out from Redstone for a brief visit with relatives and friends in Denver. They were also to make some recordings of their songs at the Rocky Mountain Radio Council, an educational project sponsored by the Ford Foundation, and their good friend Anne Downs had planned a songfest on March 13. The excited family drove out of the snowbound mountains for Denver.

Two days later, March 9, 1946, the devastating news filtered through the town—Frank Mechau was dead, victim of a heart attack. Family, friends, colleagues were consumed with disbelief and sorrow.

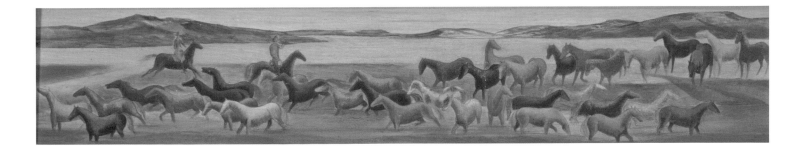

The Artist's Creative Insight

The prime condition of the artist's creative insight is to seize upon essentials. And of paramount importance is the matter of experience. Art should be an enlargement of some profound experience...

Mechau's fascination with nature appears in his journals and letters whether they are written in the high country of Colorado, the desert dryness of Arizona, or in the luxuriant jungle growth of Central America. One of his most brilliant and penetrating analyses of the interaction between the artist and nature exists in a paper which Mechau wrote at Columbia University.

Although the manuscript focuses on the art of Japan, Mechau demonstrates his ability to observe and understand art and life. And in it he reveals some of his deepest convictions.

At the turn of the century, artists in Europe and America were striking sparks from many new sources. They found that Greece and Italy were not the only cultures which had produced art. The Orient had poured forth a wealth of color and ideologies which stimulated many of our best artists.

Chinese, Persian and Japanese paintings, prints, textiles and ceramics found their way to European and American centers of culture. De Goncourt wrote a splendid appreciation of Japanese art in 1895. The prints immediately affected the work of Whistler, Degas, Van Gogh, Gauguin, Toulouse-Lautrec and others. In our own country Frank Lloyd Wright stepped forward as our greatest artist, tipped his hat to the Orient, thumbed his nose at the well-worn European traditions, bowed and pulled a one-man revolution out of his hat with the aid of Japanese antecedents. . . .

Autumn Roundup 1945
Oil and pencil on canvas
21 1/2 × 45 1/2
Diane Hornbrook
Denver, Colorado

We know that peoples and races are much alike fundamentally and that art is a universal language that binds us together in our hopes and common experiences. There are minor differences which are important to the producing artists but of secondary importance to the layman. It is interesting to consider these differences so as to enlarge our understanding and aesthetic intake.

It may be a dangerous simplification to say that one of the chief differences between Chinese and Japanese art is the sense of movement that the Japanese added to the Chinese tradition. The immense mainland of China bred on its broad horizons a feeling of solid timelessness. . . .

Historians, anthropologists, biochemists have long been interested in the effect of climate and soil on races. Japan is an archipelago off the immense life-giving and life-taking ocean. The Japanese people, not so different racially from their brothers in China and Korea, after centuries of a definite environment began to add the element of movement to their art.

When this feeling crept in we are not sure, but the solemn, immobile Chinese with their "We've got lots of time" feeling against the tense and mobile nervousness of the "up and at 'em" dynamic adaptability of the Japanese became a fact.

This feeling of movement entered Japanese art as a prime characteristic of a people who were subconsciously conditioned by life on a small, impermanent volcanic island that might at any moment erupt, or have a tidal wave sweep the island clear of life and habitations. Instinctively their artists strove to seize the essentials of movement. Their architecture grew out of this consciousness of instability; thought and action acknowledged the transitory aspect of life. . . .

If we accept the premise that architecture is the true base of painting then the composition, tone and color of a picture should be predicated by its architectural setting. This should be ever-present in the painter's or sculptor's mind. The ideal solution, of course, is to work in situ. . . .

Japanese prints, sculpture, gardening, embroideries, enamels, and crafts grew along with the architecture and each modified the other. The world of Japanese art stands as the most intellectual of the world's plastic languages. The power of stylization has

The New Filly 1944
Pencil, ink, and wash on cardboard
23 × 29 1/4
Cynthia Brown
Ashland, Oregon

never been equaled. The art grew from intensive study of nearby things. Leaves, flowers, insects, small creatures have never been observed with such incredible insight and patience. While the accident of nature dictated this interest in microscopic detail, the fog that enveloped the island led to amazing simplification in landscape compositions. Living with and depending upon nature's whims, these people came to know and love the teeming soil, sky, wind and water.

All branches of the arts flourished with an orientation unequaled in the entire history of art. These people were capable of conceiving and producing the tiniest ornament

to the largest bronze statue ever cast, a brush drawing of a blade of grass or a monumental range of mountains.

Mechau then discusses some of the doctrines which separate the aesthetics of the East from those of the West. With the suggestion that the credo of the Renaissance had been accepted as representative of European philosophy for the past 500 years, he offers Da Vinci as the ultimate example. Mechau states that Leonardo's notebook, filled with amazing inventions, served as an outstanding symbol of the technocratic culture which developed in the Western world. He points to the dominance of the human figure in the Renaissance as another distinguishing feature of Western painting—the stress on the individual as opposed to the "Eastern collective feeling."

Mechau concludes this section of his thesis with these definitive phrases: "From Da Vinci on, the battle cry was man against nature. Most of European and American energy has been expended in a rude effort to conquer the earth with the machine."

As the essay on Japanese art develops, Mechau's words evoke images from his own work—reflect the artist's own philosophical orientation. Take, for example, the discussion of movement and the rhythm of motion offered as a major characteristic of Japanese expression.

The element of motion appears in every one of Mechau's works. Within the context of enormous energy and violent activity, he seems to arrest the flow of time in an eternal moment. Forms are intertwined like the orchestrated motifs of symphonic music. His early football scenes, his compositions of "Indian Fight," the involved complexity of the "Wild Horse Race," the maelstrom of fighting men in "Battle of the Alamo"—all build to a kind of crescendo. Mechau continues his essay and then includes a quotation from Asian art scholar Laurence Binyon:

Japanese painting of the last five hundred years bears the stamp of the Asian accent of vision and imagination. The Japanese strove to seize the essentials of objects in movement either consciously or unconsciously. Plastic distortion for the sake of move-

ment is often distressing to the camera-minded European. The Eastern point of view is clearly non-photographic; the Oriental artist did not rig up an easel in front of the motif and proceed to squint, measure and document the external appearance of things. Asian art scholar Laurence Binyon expounds on this:

"It is always the essential character and genius of the element that is sought for and insisted on: the weight and mass of water falling, the sinuous swift curves of a stream evading obstacles in its way, the burst of foam against a rock, the toppling crest of a slowly arching billow; and all in a rhythm of pure lines. But the same principles, the same treatment, are applied to other subjects.

If it be a hermit sage in his mountain retreat, the artist's efforts will be concentrated on the expression, not only in the sage's features, but in his whole form, of the rapt intensity of contemplation; toward this effect every line of drapery and of surrounding rock or tree will conspire, by force of repetition or of contrast. If it be a warrior in action, the artist will ensure that we feel the tension of nerve, the heat of blood in the muscles, the watchfulness of eye, the fury of determination.

That birds shall be seen to be, above all things, winged creatures rejoicing in their flight; that flowers shall be, above all things, sensitive blossoms unfolding on pliant, up-growing stems; that the tiger shall be an embodiment of force, boundless in capacity for spring and fury—this is the ceaseless aim of these artists, from which no splendour of color, nor richness of texture, nor accident of shape diverts them.

The more to concentrate on this seizure of the inherent life in what they draw, they will obliterate or ignore at will half or all of the surrounding objects with which the Western painter feels bound to fill his background. By isolation and the mere use of empty space they will give to a clump of narcissus by a rock, or a solitary quail or a mallow plant quivering in the wind, a sense of grandeur and a hint of the infinity of life."[10]

The close kinship of Mechau's art with that of the Orient is even more clearly defined when one considers the kinship of Oriental art to the most detailed knowledge

Al Anderson and His Dogs 1936
Pencil on tracing paper
6 1/4 × 9 7/8
Paula Mechau Estate
Palisade, Colorado

Utah Landscape 1944
Pencil on tracing paper
10 1/8 × 18
Paula Mechau Estate
Palisade, Colorado

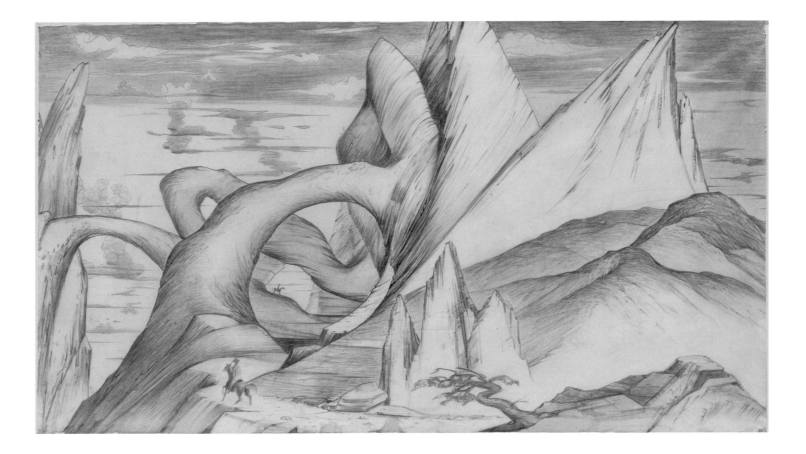

of nature. There is implicit in most of Mechau's paintings a definite union between man and nature. Often Red Mountain, Chair Mountain or Mt. Sopris serve as majestic backdrops for the small-scale adventures of man.

The Western skies—often green and mysterious, streaked with lowering clouds and filled with the brilliance of clear air—are also the subjects of Mechau's scrutiny. Particularly dramatic examples of his "sky-scapes" appear in "High Country," "Pony Express," "Autumn Roundup," and "Oil and the Old West."

Mechau's ability to delineate the regal dignity of animals is most evident in his paintings of horses. He knew their every anatomical feature because he lived with them, worked and rode them. He frequently drew them in a stylized form reminiscent of the horses in ancient Chinese art, endowing them with a kind of mystic symbolism which suggested that they were the "sum total of all that is beautiful in the animal kingdom." In "The Last of the Wild Horses" there is a perfect integration of a mountain background with the flow of horses in the foreground.

"High Country," a smaller canvas, exhibits this same felicitous combination of animals and inanimate nature—a group of wild horses, racing across a snow-covered valley, is shown against the towering peak of Chair Mountain—a convoluted land mass, crevices filled with snow, accented by spear points of timberline pines. A sky, striated with winter storm clouds, casts its pattern over the frozen rock forms. The animated, small-scale horses in the foreground are thrown into prominence by their juxtaposition to the formidable backdrop of scenery.

This same interlacing of landscape and animal forms is achieved in "Horses in Kissing Rock Canyon" where a stallion and mare are framed in massive rock formations, and again in "Deer in Moonlight" where a stag, with his crown of antlers, and a group of graceful does race in the foreground against fantastic sculptured peaks.

Mechau also scrutinizes the minutiae of nature with the same intensity that he applies to larger terrestrial forms, particularly in the highly intuitive paintings of his last period. In "Dorik and His Colt" one finds many familiar elements in the composition. A mountain- and cloud-filled sky again serve as backdrop. The interlocking branches of a gnarled tree support young Dorik as he gazes down upon his colt, which dominates

Deer in Moonlight *1946*
Oil on canvas
36 1/2 × 24 1/8
Mrs. Loo-Roughton
Colorado Springs, Colorado

the immediate foreground. The entire structure of the painting is given cohesion by the rock forms on the left which yield to the gushing spill of a waterfall.

A fairly new element in this painting is the meticulous introduction of leafy plant forms along the edge of the stream bank, echoing the precise and sensitive delineation found in the Japanese flower studies and the botanical accuracy of Dürer drawings. This same delicate reverence for the diminutive in nature appears again in the "Children's Hour." At the foot of the encircling, bare-branched trees where the Mechau children are playing, one finds a group of small flowering plants and two tiny birds searching out seeds.

In the concluding paragraphs of Mechau's essay on Japanese art, he introduces the basic principles and the general disciplines which apply to those who achieve great creativity in any field of art in all periods of history.

There is a quality in a work of art more immediate than nature itself for many of us. When something arresting has been seen, and is deeply understood and well-stated with the means at an artist's disposal, we have a profound structural and well-realized art. The organic or geometric principle is at the root of all sound organization whether it be a painting, a building or a symphony. Geometry is the grammar of form, and the language of the form is conditioned by the forces of nature in our everyday lives and by our sense of the past.

Varieties of form, line, color, texture and sounds have the acquired meaning of long cultural traditions. To illustrate the correlation between the geometry of form and associated ideas—the circle is the world and infinity; the spiral, as a portion of it, signifies generative force—cyclones, whirlpools. The pyramid is a form of great structural strength and unity, such as mountain peaks. The spire suggests aspiration, spiritual elevation, and in nature it is found in rocky pinnacles and pine trees. The square has integrity and stability in buildings and rock cliffs.

All this may sound suspiciously like a prescription, and it is, of course. If the artist depends upon a theory over nature he is automatically stalemated. He should be able to devote himself to a fragment of nature, observe it lovingly yet analytically. He should feel with his brush and his mind the attitude, character and relation of the

shapes and colors. As soon as the structural skeleton is perceived the artist has a ham-merlock on his problem.

The Japanese have been trained by ancestral traditions to observe nature in a spirit of humility. Patient studies of the masters and nature prepare him to interpret all aspects of life with well-tried tools. The prime condition of the artist's creative insight is to seize upon essentials. And of paramount importance is the matter of experience. Art should be an enlargement of some profound experience which is either actual or imaginary. Otherwise we are cursed with a literal and phlegmatic art. This can never be said of Japanese prints.

It can seldom be said about Mechau either. His best work combined his aesthetic theories with his experience of life. Constantly experimenting with painting techniques and searching for a way of expressing his American identity in his work, Mechau was unfailing in his commitment to his source of material—his own native land, the high country of the West.

As Mechau said about "Tom Kenney Comes Home" and his lithograph "The Way Home,"

Man is a restless animal. Even though born to a mountain paradise he will run away as far as the earth's surface will permit. Then the inevitable searching return. Thomas Wolfe found you can't go home again to a small town, but this forgotten valley is my way home.

AFTERWORD

~

A Commentary by Otto Karl Bach

The art of Frank Mechau stands firm in the face of great changes in the orientation of artists, art movements, art markets and art audiences in the twenty-one years since his death at the age of forty-two. During these years, his major works have been on public view in the post offices in Washington, D.C., Brownfield, Glenwood Springs, Colorado Springs and Ogalalla, in the U.S. Court of Appeals in Fort Worth, in the Denver Public Library and in art museums in New York, Detroit, Colorado Springs and Denver. During this interim, these works have unobtrusively become a part of the tradition of western painting.

Although Mechau had participated in the cubist movement as a young student in Paris, and had shaped his football players and horsemen after the paintings of Picasso, Leger and di Chirico, he split off from the movement which was becoming increasingly international and abstract, in order to pursue his solitary way as a romantic painter of his native American West. To the light, color and space of di Chirico, Mechau began to add to his work the brilliant color and tempera techniques of Gothic painters and the graphic line and composition of Oriental art which he had encountered in museums.

Returning to the United States at the depths of the great depression, Mechau was hard put to survive until the PWAP commissioned him to execute the large canvas, "Horses at Night" for the Denver Public Library. From this time on, the majority of Mechau's works were commissioned by the Federal Government, art museums and American industry.

Mechau's strength continues to lie in a splendid linear framework of graphic design. Drawing inspiration from such diverse graphic masters as Hokusai, Pieter Bruegel, Cézanne, Gauguin, George Caleb Bingham, Frederic Remington, and Winslow Homer, he refined and reshaped his intensely personal vision of western life. He reconstructed the spirit and events of the old West through boyhood memories and the surviving

Otto Karl Bach, foreword to *Frank Mechau, 1904—1946: A Retrospective Exhibition of Paintings and Drawings* (Fort Worth, TX: Amon Carter Museum of Western Art, 1967). Reprinted courtesy of the Amon Carter Museum of American Art, Fort Worth, TX.

elements of his native Colorado Western Slope...the surrounding profiles of Red Mountain, Mt. Sopris and Snowmass...ghost towns such as Aspen and Redstone where he had a studio in the old Victorian fire house...the Kenney brothers, Roxie and anonymous blacksmiths, wranglers and ranchers who still plied their trades in the horse country between Aspen and Glenwood Springs. When Mechau painted prairie fires, one knew that he had not only experienced such an event at first hand, but that he had also seen the linear flames roll across great Japanese scrolls such as the "Burning of Sanjo Palace."

Mechau worked slowly, making hundreds of drawings and color organization sketches in the course of the development of a single work from initial idea to completed mural. A craftsman par excellence and a perfectionist to the core, he went to great lengths in the completion of about sixty finished paintings in twenty years of work.

Mechau's paintings are in no way eclipsed by the works of his forerunners, Bierstadt, Remington and Russell, and stand far apart from the latter day followers of these artists. In comparing the works of Mechau with other painters of the West, one is strongly impressed by his personal vision and the appropriate style which he developed in order to express it. His visual knowledge of art history and design enabled him to change the portrayal of western life from a quasi-photographic painting to a splendid framework of space, light and color for the re-enactment of episodes of western life.

Because Mechau's work appears to be too eclectic, too abstract and too personal to conform to the popular conception and convention for representation of western history through photography and quasi-photographic illustration on the one hand, and because, on the other hand, it is too graphically representational, too out of style and too differently oriented to conform to current art conventions of international abstractionism, Mechau's work is generally not well understood today.

However, it is rarely the ebb and flow of current orientations and fashions which determine the eventual status of works of art for this is achieved by the perspective of time, by continuous comparisons, and by an understanding of the diverse and relative orientations of the artists. On this basis it seems clear that Mechau's work has an excellent chance of remaining as an important landmark in the achievement of western painting and in the establishment of a singular creative personality in its expression.

APPENDIX

"DANGERS OF THE MAIL" CONTROVERSY

The controversy over murals in the Washington, D. C. Post Office building (now the William Jefferson Clinton Building) arose again in 2000 when the U.S. Environmental Protection Agency made it its headquarters. Since that time (and at this writing), "Dangers of the Mail" has been screened from view and cannot be seen except by special arrangement.

A number of Native American EPA employees vigorously objected to the portrayals of Native Americans in six WPA-era murals in that building, which—they insisted—conveyed racist stereotypes. They complained that the murals, whatever their artistic merits, created a "hostile work environment" and demanded that they be removed or concealed. "Dangers of the Mail" especially drew their fire. Various important Native American organizations joined the call for its removal. In reaction, voices were raised against censorship and in favor of keeping the murals in place unobstructed. In November 2000, stories in the *Washington Post* and other major newspapers amplified the debate about how events in American history, specifically the confrontation between Native Americans and encroaching settlers, adventurers, or Pony Express riders, should or should not be depicted in public art.

The General Services Administration (GSA), the agency in charge of U.S. Government buildings and public art, was unable to mediate the differences between the contending parties, which included the Mechau family. As prescribed by the National Historic Preservation Act, GSA gathered public comment and in 2007 decided: 1) to leave all murals in place, 2) keep "Dangers of the Mail" out of sight except on special request, and 3) develop and display "interpretive texts."

Regrettably, the interpretive texts GSA installed in 2015 in many instances inaccurately attribute racist and sexist attitudes to the muralists and betray a dismissive and condescending tone—even toward the whole of the public art produced under the New Deal.

NOTES

1. Mechau's illustrations were in fact used as end page and wrapper designs for Richard Aldington's book of poems, *The Love of Myrrhine and Konallis*, published by Pascal Covici, Chicago, 1926. It was a 112-page edition issued in 1010 copies, of which 500 were for England and 510 for America. The first 150 copies were autographed by the author. The Denver Public Library has one in its rare book section, number 41. Mechau's end pages are executed in black ink on gold paper.

2. "1900: A Philosophy of Fine Art," delivered to the Architectural League at the Art Institute of Chicago, cited in *Frank Lloyd Wright on Architecture, Selected Writings, 1894–1940*, (Duell, Sloan and Pearce, New York, 1941), p. 17, ff.

3. Ibid., p. 18.

4. Before executing the fresco, Mechau went to San Francisco to see Bernard Zakheim, an experienced fresco artist whom he had known in Paris, for pointers on the required techniques.

5. The eleven painters awarded commissions for the Washington, D.C. Post Office were, besides Mechau, Tom Lee, Alfred Crimi, Reginald Marsh, Ward Lockwood, George Harding, Doris Lee, Karl Free, William C. Palmer, Rockwell Kent, Eugene Savage, and Alexander Brook.

6. Since 2000, due to renewed protests, "Dangers of the Mail" has been screened from view; see Appendix, page 121.

7. The pattern of Edward (Eduardo) Chavez's life (1917–1995) in some respects was like that of Mechau's. He combined painting with teaching positions at the Art Students' League in New York City, Colorado College, and Syracuse University. He received mural commissions and his work is included in major collections. He and Jenne Magafan, his wife, lived in Woodstock, New York where Ethel Magafan and her husband, Bruce Currier, also lived.

8. From *Through the American Landscape* by Kaj Klitgaard, (The University of North Carolina Press, 1941).

9. From *Esquire*, December 1946. Copyright © 1946 by Esquire Publishing, Inc.

10. Laurence Binyon as quoted by Arthur Davison Ficke in *Chats on Japanese Prints* (Frederick A. Stokes Co., 1917), pp. 34–35.

PHOTOGRAPHIC CREDITS

Randy Batista Photography — 56

Robert C. Bishop — 71

Colorado Springs Fine Arts Center — 32, 38–39, 40–41

Denver Art Museum — 17, 33, 34, 35

Denver Public Library — 23
 Black and white photographs — 53 (top right and top left)

Paula Mechau Estate — 8, 27, 30, 30–31,
 Black and white photographs — 7, 10, 13, 32, 53 (bottom right and bottom left)
 60, 68, 69, 72, 79, 96

Metropolitan Museum, New York — 48–49

Nebraska Historical Society — 46

William J. O'Connor Photography — 14, 15, 19, 20, 26, 28, 45, 50, 62-63,
 74, 93, 97, 98, 107, 109, 113, 115, back dust jacket detail

Orion Studios, Santa Fe, New Mexico — 38–39, 40–41, 95

Gerald Peters Gallery, Santa Fe, New Mexico — 16

Philbrook Musuem of Art, Tulsa, Oklahoma — 100, 103

Sheldon Museum of Art, Lincoln, Nebraska — 31

Mark Stephenson — 89, front cover, front dust jacket

Shawn Tolle — 21, 92, 105, 112

Texas A & M University Press — 57, 66, 67

U.S. Center of Military History — 77, 80, 81, 83, 84, 85, 86

1927 Group exhibition, Architectural League, New York

1931 *Les Surindépendents "Quatriéme Exposition"*
 Association Artistique de Paris
 Parc des Expositions, Porte de Versailles

1932 *30 Meilleurs Peintres Américains de Paris*
 Gallerie de Renaissance, Paris

1933 One-person exhibition, Junior League of Denver Gallery

 39th Annual Exhibition, Denver Art Museum

1934 *National Exhibition of Selected Works from Public Works
 of Art Project (PWAP)*
 Corcoran Gallery, Washington, D.C.

 1st National Exhibition of American Art
 Rockefeller Center International Building, New York

 Selected Works of Public Works of Art Project (PWAP)
 Museum of Modern Art, New York

 Whitney Biennial of Contemporary American Painting
 Whitney Museum of American Art, New York

1935 *Exhibition of Four Guggenheim Fellows*
 Midtown Gallery, New York

 Biennial of Contemporary American Painting
 Whitney Museum of American Art, New York

 1st Annual Exhibition of Paintings by Artists West of the Mississippi
 Colorado Springs Fine Arts Center

 46th Annual Exhibition of American Painting and Sculpture
 Art Institute of Chicago

 Exhibition of Mural Sketches for Public Works of Art Project (PWAP)
 Midtown Gallery, New York

 *Exhibition of Small Scale Designs for the Treasury Relief Art
 Project (TRAP) Entries for Washington, D.C. Federal Buildings*
 Corcoran Gallery, Washington, D.C.

1936 *A Selection of Treasury Department Mural Designs*
 Whitney Museum of American Art, New York

Biennial Exhibition of Contemporary American Painting
Virginia Museum of Fine Arts, Richmond

42nd Annual Exhibition, Denver Art Museum

*2nd Annual Exhibition of Paintings by Artists West
 of the Mississippi*
Colorado Springs Fine Arts Center

Paintings and Sculpture Executed under Treasury Relief Art Project
Whitney Museum of American Art, New York

1st Anniversary Exhibition of Contemporary American Painting
Walker Art Galleries, New York

1937 *Exhibition of Drawings by American Artists, Past and Present*
 Phillips Memorial Gallery, Washington, D.C.

 15th Biennial Exhibition of American Oil Painting
 Corcoran Gallery, Washington, D.C.

 3rd Annual Exhibition of Paintings by Artists West of the Mississippi
 Colorado Springs Fine Arts Center

 International Exhibition of Paintings, Carnegie Institute, Pittsburgh

 Group Exhibition, National Society of Mural Painters
 Whitney Museum of American Art, New York

 Paintings for Paris, Museum of Modern Art, New York

1938 *113th Annual Exhibition*
 The National Academy, New York

 Trois Siécles d'Art aux États-Unis
 Le Musée de Jeu de Paume, Paris

 *Exhibition of Small Scale Sketches for the Treasury Relief
 Art Project Competition for the Dallas Post Office*
 Dallas Museum of Fine Arts

 4th Annual Exhibition of Paintings by Artists West of the Mississippi
 Colorado Springs Fine Arts Center. Traveled to the Denver Art
 Museum; Whitney Museum of American Art, New York; and
 the Dayton Art Institute.

 49th Annual Exhibition of American Art
 Art Institute of Chicago

Carnegie Annual International Exhibition
Carnegie Institute, Pittsburgh

1939 *Frontiers of American Art*
De Young Museum, San Francisco

One-person Exhibition
East Hall, Columbia University, New York

1940 *Contemporary American Art*
Nebraska Art Association Sheldon Memorial Art Gallery, Lincoln

Cranbrook-Life Exhibition of Contemporary American Painting
Cranbrook Academy of Art, Bloomfield Hills, Michigan

1942 *53rd Annual Exhibition of American Painting*
Art Institute of Chicago

Artists for Victory
Metropolitan Museum of Art, New York

1944 *Exhibition of Contemporary American Art*
Nebraska Art Association, Sheldon Memorial Art Gallery, Lincoln

Paintings in the United States
Carnegie Institute, Pittsburgh

1945 *Premier Showing of Caribbean and Pacific Paintings from the War Unit*
Chappell House Gallery of the Denver Art Museum

56th Annual Exhibition of American Painting
Art Institute of Chicago

The Encyclopedia Britannica Collection of Contemporary American Paintings
Art Institute of Chicago; Rockefeller Center, New York; Boston Museum of Fine Arts; Corcoran Gallery, Washington, D.C.; Dayton Art Institute; Carnegie Institute, Pittsburgh

7th Annual Exhibition of Paintings by Artists West of the Mississippi,
Colorado Springs Fine Arts Center

Paintings in the United States
Carnegie Institute, Pittsburgh

1946 *Paintings by American Artists*
John Herron Institute, Indianapolis

Oil, 1940–45 (an exhibition of documentary paintings from the collection of the Standard Oil Co., New Jersey)
Associated Gallery, New York

The Encyclopedia Britannica Collection of Contemporary American Paintings
Syracuse Museum of Fine Arts; Cincinnati Art Museum; Detroit Institute of Arts; Milwaukee Art Institute; Minneapolis Institute of Arts; John Herron Art Institute, Indianapolis

Frank Mechau Memorial Exhibition, Denver Art Museum

1947 *The Encyclopedia Britannica Collection of Contemporary American Paintings*
William Rockhill Nelson Gallery/Atkins Museum, Kansas City, Missouri; City Art Museum of St. Louis; Denver Art Museum

Frank Mechau Memorial Exhibition
William Rockhill Nelson Gallery/Atkins Museum, Kansas City

1948 *Frank Mechau,* Colorado Springs Fine Arts Center

1949 *The Modem Artist and His World,* Denver Art Museum

1960 *The Life Magazine Collection of Art from World War II*
Pentagon, Washington, D.C.

1967 *Frank Mechau, 1904–1946*
Amon Carter Museum, Fort Worth, Texas

1972 *Frank Mechau Retrospective,* Denver Art Museum

1973 *Recent Acquisitions for the Woods Charitable Fund*
Nebraska Art Association, Sheldon Memorial Art Gallery, Lincoln

1974 *American Masters of the West*
Boise Gallery of Art, Boise, Idaho; Utah Museum of Fine Arts, University of Utah, Salt Lake City

1981–82 *Frank Mechau: Artist of Colorado*
The Aspen Center for the Visual Arts, Aspen, University of Colorado Art Galleries, Boulder

2001 *Frank Mechau: An Intimate Portrait of a Colorado Master*
Grand Junction Fine Arts Center, Grand Junction, Colorado

2005 *Shooting Star: The Artwork of Frank Mechau (1904–1946)*
Denver Public Library

2016 *Fine Arts Center Legacy Series: Frank Mechau*
Colorado Springs Fine Arts Center

CATALOG OF WORKS

PAINTINGS

Horses at Night, (study) 1928
oil/canvas, 11 × 26
Duna and Jack Stephens, Palisade, CO

Self-Portrait, 1928
oil/canvas, 13 × 9 1/4
Paula Mechau Estate, Palisade, CO

Semi-Abstraction, 1929
oil/canvas, 35 × 48

La Statue Fatiguée, 1929
oil/canvas

Abstraction Mécanique, 1930
oil/canvas, 38 × 38
Gerald Peters Family Foundation,
Santa Fe, NM

Football, n.d.
oil/panel, 13 × 11
Paula Mechau Estate, Palisade, CO

The Riders, France, 1930
oil/canvas, 18 1/8 × 25 5/8
Kirkland Museum of Fine and
Decorative Art, Denver, CO

L'Acrobat, 1930
oil/canvas, 36 1/8 × 23 1/2
Paula Mechau Estate, Palisade, CO

Basketball in a Paris Court, 1930
oil/canvas, 15 × 18 1/8
B.W. Holmbaker, Boulder, CO

Studio Scene, 1930
oil/wood, 19 1/4 × l2 1/8
Paula Mechau Estate, Palisade, CO

Pool Scene, 1930
oil/canvas, 20 1/2 × 18 1/2
John Goldstein, Denver, CO

Petite Nu, c. 1930
oil/canvas

Paula in the Tub, 1930
oil/canvas, 23 3/4 × 28 3/4
Polly Downer Hough, Salt Lake City, UT

Rodeo Pickup Man, c 1930
oil/canvas, 31 3/4 × 39 1/4
Denver Art Museum, Denver, CO

Branding, n.d.
oil/panel, 4 × 10

Abstraction / Ballplayers, 1931
oil/canvas, 38 × 48
Denver Art Museum, Denver, CO

Indian Fight #2, 1931
oil/canvas, 36 5/8 × 45 3/4
Paula Mechau Estate, Palisade, CO

Horses at Night, 1932

Horses in Moonlight, 1932
oil and pencil/canvas, 30 1/8 × 38
Harvey Allon, Denver, CO

Two Horses in a Storm, 1932
oil/panel, 15 5/8 × 19 3/4
Vanni Lowdenslager, Gunnison, CO

Sketch for Football Composition, 1932
oil/board, 27 × 62
Paula Mechau Estate, Palisade, CO

Football Abstraction, 1932
oil/canvas, 26 3/4 × 68 1/8
Robert Lewis, Denver, CO

Indian Fight #1, 1933
oil/canvas, 32 × 45 3/4
Paula Mechau Estate, Palisade, CO

Night Herd, 1934
pastel, 10 1/2 × 25
Denver Public Library, Denver, CO

Rodeo #1, 1934
oil/canvas, 39 × 84
Denver Art Museum, Denver, CO

Indian Fight #3, 1934
oil/canvas, 35 1/4 × 47 1/4
Sheldon Memorial Art Gallery
Lincoln, NB

Dangers of the Mail, 1935
(study for Washington, DC mural)
oil, tempera, pencil/paper
25 × 54 1/2
Colorado Springs Fine Arts Center
Colorado Springs, CO

Pony Express, 1935
(study for Washington, DC mural)
oil/paper, 25 × 54 1/2
Colorado Springs Fine Arts Center
Colorado Springs, CO

Dangers of the Mail, 1935
(study for Washington, DC mural)
oil, tempera, pencil/paper, 25 × 54 1/2
Jeffrey & Leslie Modesitt
Littleton, CO

Pony Express, 1935
(study for Washington, DC mural)
oil/paper, 25 × 54 1/2
Jeffrey and Leslie Modesitt
Littleton, CO

Stampede, c. 1935
oil/panel, 6 3/8 × 17 1/4
Samuel P. Harn Museum of Art
University of Florida, Gainesville

Pony Express, c. 1935
oil/panel, 4 1/2 × 25 1/2
Samuel P. Harn Museum of Art
University of Florida, Gainesville

Watering the Horse Herd, 1936
oil/panel, 4 1/2 × 20 1/4
Duna and Jack Stephens, Palisade, CO

Horses Crossing Dunes, c. 1936
oil/canvas, 13 3/4 × 43 1/2
Braddock Financial, Denver, CO

Longhorn Drive, 1937
oil/masonite, 13 × 40 1/2
Peter R. Coneway
Riverstone Energy, Houston, TX

Running Horses, n.d.
tempera/panel, 4 1/4 × 10
Joan Farber, New York, NY

Winter Pastures, 1937
(study for fresco at
Colorado Springs Fine Arts Center)
oil/panel, 8 × 86 3/4
Detroit Institute of Arts, Detroit, MI

Red Mountain, 1937
oil and pencil/canvas, 19 7/8 × 64
Timothy F. Marquand, New York, NY

The Last of the Wild Horses, 1937
oil/canvas, 40 × 100
Metropolitan Museum, New York, NY

Stallion and Mares, (study) 1937
ink, pencil, oil, wash/cardboard
22 5/8 × 38 1/2
University of Denver, Denver, CO

Stallion and Mares, 1937
tempera/panel, 23 1/4 × 42 1/2

High Country, 1937-38
oil/canvas, 23 5/8 × 48 3/8
Lisa Cattermole, Wilmington, DE

Battle of the Adobe Walls, n.d.
tempera/panel, 6 1/2 × 36
Century Club, New York, NY

Battle of the Alamo, 1938
tempera/masonite, 15 1/4 × 49 1/2
Paula Mechau Estate, Palisade, CO

Barroom Brawl, c. 1938
tempera/masonite, 6 1/2 × 17 1/2
Morgan Smith, Santa Fe, NM

Bowie, Houston, and Crockett, c. 1938
oil and pen/masonite, 10 7/8 × 16 3/4
Emma Martin, Denver, CO

Prairie Fire Set by Rustlers, 1938
tempera/panel, 6 3/8 × 17 5/8
Pat Stein Spitzmiller, Dillon, CO

Mountain Peaks, 1940
oil/panel, 14 1/4 × 19 1/4
Paula Mechau Estate, Palisade, CO

Forest Fire, c. 1940
oil and tempera/panel
28 3/8 × 69 1/8
Paula Mechau Estate, Palisade, CO

Mountain Parks, n.d.
oil/panel, 19 × 24
Paula Mechau Estate, Palisade, CO

South Park (sketch), n.d.
oil and pencil/cardboard, 22 × 39
Paula Mechau Estate, Palisade, CO

Deer in Winter, n.d.
oil/panel, 15 × 30

Frank Talking to Roxie, (study) 1942
tempera/panel, 11 1/2 × 38
Paula Mechau Estate, Palisade, CO

High Water, 1942
oil and pen/panel, 15 7/8 × 9 7/8

High Water, 1942
oil/panel, 36 1/4 × 21 1/4
Paula Mechau Estate, Palisade, CO

High Water, 1942
oil/panel, 36 1/4 × 21 1/4

Saturday, P.M., (study), c. 1942
tempera and pencil/panel
29 5/8 × 35 5/8
Paula Mechau Estate, Palisade, CO

Saturday, P.M., (study) c. 1942
oil and charcoal/paper, 15 3/4 × 19 3/4
Nick Arndt, Denver, CO

Saturday P.M., 1942
tempera/panel, 30 1/4 × 36 1/8
Denver Art Museum, Denver, CO

Law Comes to the Panhandle, n.d.
tempera, 5 3/4 × 6 1/2

—————————

The following paintings are part of the
Army Art Collection, U.S. Army Center
of Military History, Fort McNair, DC

Angry San Blas Girl, 1943–44
oil and ink/canvas, 32 1/8 × 39

Coconut Grove, Panama, 1943–44
dry brush oil/canvas, 35 5/8 × 27

Darien Indians, Panama, 1943–44
oil and ink/canvas, 32 1/8 × 27

Death by Water, 1943–44
oil/canvas, 26 1/2 × 42

Early Morning Bombing, 1943–44
oil/canvas, 30 1/8 × 23

Incoming Planes, 1943–44
oil/canvas, 13 1/8 × 24 7/8

Juke Box Blues, 1943–44
oil, pencil and ink/canvas
19 1/2 × 36 1/2

Jungle Encounter, Panama, 1943–44
oil/canvas, 32 × 23 3/4

Lone Patrol, 1943–44
oil and ink/canvas, 26 3/4 × 41

Lookout and Weather Tower, 1943–44
oil and ink/panel, 17 3/4 × 24 3/4

San Blas Beach, 1943–44
oil and ink/panel, 14 3/4 × 25 1/8

—————————

Tom Kenney Comes Home, 1944
tempera/masonite, 30 3/4 × 47 1/2
Robert Lewis, Denver CO

Dorik and His Colt, (study) 1944
oil/canvas, 9 5/8 × 9 1/2
Nora Fisher, Santa Fe, NM

Dorik and His Colt, (study) n.d.
oil/canvas, 10 × 13
Paula Mechau Estate, Palisade, CO

Dorik and His Colt, 1944
oil/canvas, 32 × 39 3/8
Shirley Gustafson, Denver, CO

Old Pine, 1944
oil/canvas, 15 × 7
Jim Roughton, Denver CO

The Christmas Tree, n.d.
watercolor and pencil/paper
5 7/8 × 7 5/8
Jim Roughton, Denver CO

Autumn Roundup, 1945
oil and pencil/canvas, 21 1/2 × 45 1/2
Diane Hornbrook, Denver, CO

Red Mare, 1945
oil/paper, 14 × 20

Oil and the Old West, 1945
tempera/panel, 51 × 31
The Philbrook Art Center, Tulsa, OK
Standard Oil of New Jersey Collection

Gas Flares, Elk Basin, Wyoming, 1945
egg tempera/masonite, 35 1/4 × 26
The Philbrook Art Center, Tulsa, OK
Standard Oil of New Jersey Collection

Burning the Waste Oil, 1945
tempera/panel, 51 × 31

Tank Flare and Waste Pool, 1945
tempera/panel, 51 × 31

Pet Eagle of Elk Basin, 1945
tempera/panel, 51 × 31

Pet Eagle of Elk Basin, Wyoming, 1945
oil, ink and pencil/masonite
20 7/8 × 36

Rocks in Redstone Canyon, n.d.
oil/canvas, 36 × 26
Paula Mechau Estate, Palisade, CO

Canyon Rocks, c. 1945
oil/canvas, 32 × 25 5/8
Paula Mechau Estate, Palisade, CO

Horses in Kissing Rock Canyon, 1945
oil/canvas, 40 1/8 × 38 3/8
David Shepherd, Santa Fe, NM

Children's Hour, 1945
oil/canvas, 32 × 40
Paula Mechau Estate, Palisade, CO

Deer in Moonlight, 1946
oil/canvas, 36 1/2 × 24 1/8
Mrs. Loo-Roughton, Colorado Springs, CO

MURALS

Horses at Night, 1934
oil/canvas, 63 1/4 × 144 1/2
Denver Public Library
Western History Department
U.S. General Services Administration
Fine Arts Collection

Pony Express, 1935
tempera/canvas, 60 × 132 1/4
William Jefferson Clinton Building
Washington, DC
U.S. General Services Administration
Fine Arts Collection

Dangers of the Mail, 1935
tempera/canvas, 66 × 144
William Jefferson Clinton Building
Washington, DC
U.S. General Services Administration
Fine Arts Collection

Indian Fight, c. 1936
oil/canvas, c. 66 × 144
Denver Federal Center, Denver, CO
(Originally in the Post Office
Building, Colorado Springs, CO)
U.S. General Services Administration
Fine Arts Collection

The Corral / Pony Express, c. 1936
oil/canvas, 66 × 144
Byron Rogers U.S. Courthouse
Denver, CO
(Originally in Post Office Building
Colorado Springs CO)
U.S. General Services Administration
Fine Arts Collection

Wild Horse Race, c. 1936
tempera/canvas, 59 3/4 × 133
Byron Rogers U.S. Courthouse
Denver, CO
(Originally in the Post Office
Building, Glenwood Srings, CO)
U.S. General Services Administration
Fine Arts Collection

Wild Horses (panels), 1936
tempera/wood, 60 feet long
(6 panels 45 3/4 × 102 each)
Denver Art Museum, Denver, CO

Wild Horses (fresco), 1936
45 3/4" × 60'
Colorado Springs Fine Arts Center
Colorado Springs, CO

Longhorns, 1938
oil/canvas
47 1/2 × 144
Post Ofrce Building, Ogallala, NB
U.S. General Services Administration
Fine Arts Collection

Fighting a Prairie Fire, 1938
oil/canvas, 66 × 144
Brownfield Police Department
(formerly Post Office Building)
Brownfield, TX
U.S. General Services Administration
Fine Arts Collection

Texas Rangers, 1940
oil/canvas, 96 × 125
Eldon B. Mahon U.S. Courthouse
Fort Worth, TX
U.S. General Services Administration
Fine Arts Collection

Tbe Taking of Sam Bass, 1940
oil/canvas, 96 × 130
Eldon B. Mahon U.S. Courthouse
Fort Worth, TX
U.S. General Services Administration
Fine Arts Collection

Flags Over Texas, 1940
oil/canvas, 38 × 69
Eldon B. Mahon U.S. Courthouse
Fort Worth, TX
U.S. General Services Administration
Fine Arts Collection

DRAWINGS

Salome, c. 1924
ink/paper, 6 3/4 × 19
Lavonne and Floyd Diemoz
Glenwood Springs, CO

Portrait of Paula, 1929
lithographic pencil/paper
11 3/4 × 9 1/4
Paula Mechau Estate, Palisade, CO

Rodeo, n.d.
pencil/paper, 5 × 8
Paula Mechau Estate, Palisade, CO

Stampede, c. 1935
pencil/tracing paper, 6 5/8 × 17 3/8
Vanni Lowdenslager, Gunnison, CO

Branding, n.d.
pencil/paper, 5 × 9
Paula Mechau Estate, Palisade, CO

Indian Fight, n.d.
gouache and pencil/paper, 16 × 36
Paula Mechau Estate, Palisade, CO

Wild Horse Race, n.d.
pencil/paper, 2 3/4 × 7 1/2
Paula Mechau Estate, Palisade, CO

Forest Fire, n.d.
pencil and crayon/paper, 12 × 18
Paula Mechau Estate, Palisade, CO

Horses at Night, n.d.
pencil/paper, 6 1/4 × 14
Paula Mechau Estate, Palisade, CO

Al Anderson and His Dogs, 1936
pencil/tracing paper, 6 1/4 × 9 7/8
Paula Mechau Estate, Palisade, CO

John Kenney Shoeing a Horse, n.d.
pencil/paper, 7 × 9
Paula Mechau Estate, Palisade, CO

John Kenney Shoeing a Horse, n.d.
pencil/tracing paper, 17 7/8 × 21 3/4

Pony Express (three pieces), n.d.
pencil/paper, 25 × 160
Paula Mechau Estate, Palisade, CO

Wild Horses
pencil/paper, 12 1/2 × 18 1/2

Circling Horses, 1937
pencil/tracing paper, 14 1/2 × 19 1/4
Paula Mechau Estate, Palisade, CO

Five Horses, c. 1937
lithographic crayon/paper
13 7/8 × 18 1/8
Colorado Springs Fine Arts Center
Colorado Springs, Colorado

The Last of the Wild Horses, 1937
pencil/tracing paper, 7 × 14 1/2
Vanni Lowdenslager, Gunnison, CO

Two Running Horses, n.d.
pencil/paper, 7 1/2 × 12 1/2
Paula Mechau Estate, Palisade, CO

The Way Home, n.d.
pencil/tracing paper, 10 1/2 × 23 1/4
Dorik Mechau, Sitka, AK

Stallion and Mares, 1937
pencil/paper, 3 3/4 × 15 7/8
Paula Mechau Estate, Palisade, CO

Stallion and Mares, 1937
pencil/paper, 10 × 18
Paula Mechau Estate, Palisade, CO

Stallion and Mares, 1937
pencil/paper, 29 × 39
Paula Mechau Estate, Palisade, CO

Stallion and Mares, 1937
pencil/paper, 7 1/4 × 17 1/4
Paula Mechau Estate, Palisade, CO

Stallion and Mares, n.d.
pencil/paper, 8 × 22
Denver Art Museum, Denver, CO

High Country, n.d.
pencil/tracing paper, 10 1/2 × 21 1/2
Gary Holthaus, Anchorage, AK

High Country, n.d.
pencil/paper, 8 1/4 × 34
Paula Mechau Estate, Palisade, CO

Horses, South Park, Colorado, n.d.
pencil/tracing paper, 21 × 38 1/4
Paula Mechau Estate, Palisade, CO

Wild Horses in South Park, n.d.
pencil/tracing paper, 5 3/4 × 10 1/4
Nora Fisher, Santa Fe, NM

South Park, n.d.
pencil/paper, 24 × 39
Paula Mechau Estate, Palisade, CO

South Park, n.d.
pencil/paper, 6 × 11
Paula Mechau Estate, Palisade, CO

Battle of the Alamo, 1937
pencil/tracing paper, 15 3/4 × 41 1/4
Kirkland Museum of Fine and
Decorative Art, Denver, CO

Battle of the Alamo, 1937
pencil/tracing paper, 15 1/2 × 32 3/4

Battle of the Alamo, 1937
pencil/tracing paper, 15 1/2 × 24
Fionnuala and Mark Mechau,
El Paso, TX

Texas Rangers
pencil/tracing paper, 14 3/4 × 21 5/8
Paula Mechau Estate, Palisade, CO

Barroom Brawl, c. 1938
pencil/tracing paper, 6 1/2 × 17 3/8
Vanni Lowdenslager, Gunnison, CO

Bowie, Houston, and Crockett,
c. 1938
pencil/tracing paper
14 5/8 × 10 3/4
Paula Mechau Estate, Palisade, CO

Bowie, Houston, and
Crockett, (study) c.1938
watercolor and pencil/paper
15 3/8 × 12
Paula Mechau Estate, Palisade, CO

The Taking of Sam Bass, 1938
pencil/tracing paper, 15"x 22"
Denver Art Museum, Denver CO

The Taking of Sam Bass, 1938
pencil/paper, 13 × 18

Fort Worth Texas Rangers, 1938
pencil/tracing paper
14 3/4 × 21 5/8

Prairie Fire, 1938
pencil/tracing paper, 10 7/8 × 23 3/4
Paula Mechau Estate, Palisade, CO

The Prospector, 1940
pencil/tracing paper, 6 1/2 × 11
David and Janet Robertson, Boulder, CO

Deer in Winter, n.d.
pencil/tracing paper, 11 3/4 × 34
Paula Mechau Estate, Palisade, CO

Frank Talking to Roxie, 1942
pencil/tracing paper, 11 1/2 × 37 1/4
Paula Mechau Estate, Palisade, CO

Frightened Colt, n.d.
pencil/paper, 11 × 18
Paula Mechau Estate, Palisade, CO

New Colt, n.d.
pencil/paper, 23 × 29
Paula Mechau Estate, Palisade, CO

The New Colt, 1942
pencil/paper, 5 7/8 × 7 7/8
Paula Mechau Estate, Palisade, CO

Longhorn Drive, c. 1942
pencil/tracing paper, 13 1/2 × 43

Horses Fleeing Forest Fire, c, 1942
pencil/tracing paper, 11 1/2 × 17
Paula Mechau Estate, Palisade, CO

Saturday P.M., c. 1942
pencil/paper, 22 1/2 × 28
Paula Mechau Estate, Palisade, CO

Saturday P.M., c. 1942
pencil/tracing paper, 28 1/2 × 34 1/2
Paula Mechau Estate, Palisade, CO

Saturday P.M., c. 1942
pencil/tracing paper, 6 1/8 × 7
Paula Mechau Estate, Palisade, CO

Wild Horses, c. 1943
pencil/paper, 6 5/8 × 11 5/8
Elizabeth Gartner, Grand Junction, CO

Horses Around a Water Hole, 1943
pencil/tracing paper, 23 3/8 × 40 1/4
Paula Mechau Estate, Palisade, CO

Horses Around a Water Hole, n.d.
pencil/paper, 7 × 12
Dorik Mechau, Sitka, AK

Horses Around a Water Hole, 1943
pencil/paper, 7 1/4 × 17 7/8
Paula Mechau Estate, Palisade, CO

Horse Fight, n.d.
pencil/tracing paper, 25 1/8 × 39 1/4
Nora Fisher, Santa Fe, NM

Horses Fighting, 1943
pencil/tracing paper, 9 3/4 × 17 1/4
Paula Mechau Estate, Palisade, CO

Horses Fighting, 1943
charcoal/tracing paper, 23 1/2 × 40 3/8
Paula Mechau Estate, Palisade, CO

Horses Fighting, 1943
pencil/tracing paper, 9 × 14
Paula Mechau Estate, Palisade, CO

Horses Fighting, 1943
pencil/paper, 13 3/4 × 18 3/8
Paula Mechau Estate, Palisade, CO

Battle of the Adobe Walls, n.d.
pencil/tracing paper, 7 × 34 3/4
Dorik Mechau, Sitka, AK

Angry San Blas Indian Girl, n.d.
pencil/tracing paper, 19 1/4 × 17
Paula Mechau Estate, Palisade, CO

Cayucas, 1943
pencil/paper, 4 3/4 × 9 1/8
Paula Mechau Estate, Palisade, CO

Coconut Grove, Panama, 1943
pencil/tracing, 7 1/2 × 5 3/8
Paula Mechau Estate, Palisade, CO

Darien Indians, 1943
pencil/paper, 22 × 18
Caleb and Claudia Bach

Darien Lovers, 1944
pencil/tracing paper, 10 1/2 × 5 1/2
Paula Mechau Estate, Palisade, CO

Darien Lovers, 1944
pencil/watercolor board
28 3/8 × 21 7/8

Darien Lovers, 1944
pencil/tracing, 35 × 21
Paula Mechau Estate, Palisade, CO

Ponderosa Pine, n.d.
pencil/paper, 12 × 7
Paula Mechau Estate, Palisade, CO

Lone Pine, 1944
pencil/tracing paper, 12 1/4 × 6 5/8
Paula Mechau Estate, Palisade, CO

Tom Kenney Comes Home
(study), 1944
pencil/tracing paper 29 1/2 × 46 1/2
Paula Mechau Estate, Palisade, CO

Tom Kenney Comes Home, n.d.
pencil/paper, 11 × 14
Paula Mechau Estate, Palisade, CO

Utah Landscape, 1944
pencil/tracing paper, 10 1/8 × 18
Paula Mechau Estate, Palisade, CO

High Water, n.d.
pencil/paper, 8 × 5 1/2
Paula Mechau Estate, Palisade, CO

High Water, n.d.
pencil and charcoal, 36 × 21
Paula Mechau Estate, Palisade, CO

Glenwood Canyon, n.d.
pencil/paper, 7 × 9
Paula Mechau Estate, Palisade, CO

Red Mountain After Rain, n.d.
pen and ink/paper, 4 3/4 × 17 1/2

Dorik and His Colt, n.d.
pencil/tracing paper, 10 1/4 × 12 3/4
Paula Mechau Estate, Palisade, CO

Dorik and His Colt, 1944
pencil/tracing paper
Paula Mechau Estate, Palisade, CO

Dorik and His Colt, 1944
pencil/paper, 7 3/8 × 8 7/8
Paula Mechau Estate, Palisade, CO

Curly the Calf, n.d.
pencil/cardboard, 3 × 2
Paula Mechau Estate, Palisade, CO

The New Filly, 1944
pencil, ink and wash/cardboard
23 × 29 1/4
Cynthia Brown, Ashland, OR

The New Filly, 1944
ink/paper, 17 × 25
Dorik Mechau, Sitka, AK

The New Filly, 1944
pencil/paper, 23 1/2 × 30

Redstone Balladeers (Children in the Surrey), 1944
pencil/paper, 5 3/8 × 10 1/4
Paula Mechau Estate, Palisade, CO

The Christmas Tree, n.d.
pencil/tracing paper, 5 5/8 × 6 7/8
Paula Mechau Estate, Palisade, CO

Early Sorrow, n.d.
pencil/paper, 2 1/2 × 1 3/4
Paula Mechau Estate, Palisade, CO

Early Sorrow, n.d.
pencil/tracing paper, 14 3/8 × 12 3/8
Paula Mechau Estate, Palisade, CO

Deer in Moonlight, n.d.
pencil/paper, 7 × 11
Paula Mechau Estate, Palisade, CO

Autumn Roundup, 1945
pencil/tracing paper, 16 1/2 × 23 1/4
Kristian and Annette Stephens,
Palisade, CO

Oil and the Old West, 1945
pencil/tracing paper 11 3/8 × 21 1/2

Oil and the Old West, n.d.
pencil/paper, 6 × 10
Paula Mechau Estate, Palisade, CO

Pet Eagle, n.d.
pencil/paper, 7 × 12
Paula Mechau Estate, Palisade, CO

Burning Waste, n.d.
pencil/paper, 11 × 18
Paula Mechau Estate, Palisade, CO

Horses from High Country, 1945
pencil and wash/paper, 8 × 34 1/8
Paula Mechau Estate, Palisade, CO

Horses in Kissing Rock Canyon, 1945
pencil/tracing paper, 4 × 5
Paula Mechau Estate, Palisade, CO

Children's Hour, 1945
pencil/tracing paper, 8 3/4 × 13 7/8
Mary Mills, Grand Junction, CO

Children's Hour, 1945
pencil/tracing paper, 8 5/8 × 11 7/8
Paula Mechau Estate, Palisade, CO

Children's Hour, 1945
pencil/tracing paper, 10 × 12 1/2
Paula Mechau Estate, Palisade, CO

———————————

Many unlisted sketches remain in possession of the Mechau family, and the Denver Art Museum holds numerous tracings.

LITHOGRAPHS

The Way Home, 1945
lithograph, 8 1/2 × 13
limited edition

The Last of the Wild Horses, 1937
lithograph, 6 5/8 × 14
limited edition

Horses at Night, c. 1934
lithograph, 6 × 13
limited edition

Red Mountain, 1938
lithograph, 4 1/4 × 17
limited edtion

Horses in Kissing Rock Canyon, 1945
lithograph, 10 × 14
limited edition

Red Mare, 1945
hand-colored lithograph, 10 × 14
limited edition